MICHAEL ROCKEFELLER

New Guinea Photographs, 1961

KEVIN BUBRISKI

Foreword by ROBERT GARDNER

Peabody Museum Press
Harvard University

CONTENTS

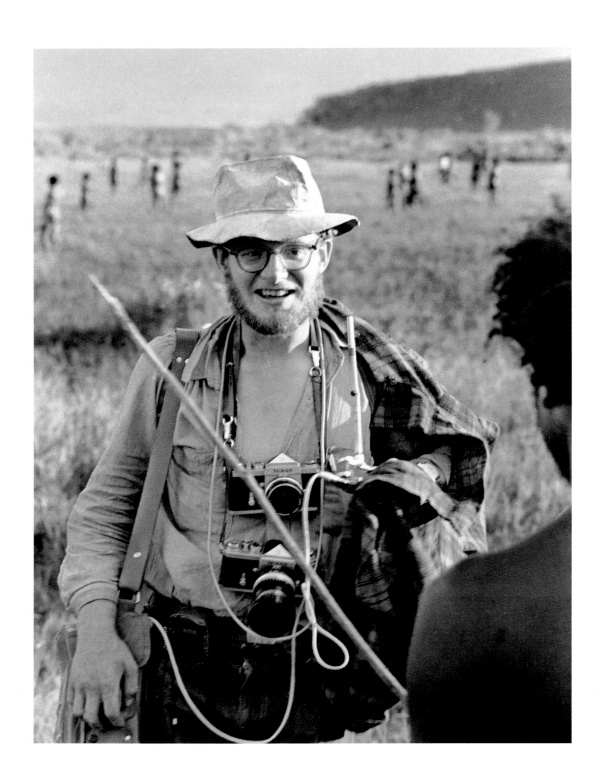

FOREWORD

It was Michael Rockefeller's eyes that first caught, and never quite escaped, my attention. I cannot recall their color, but I do remember how he peered out at the world in an inquiring, even quizzical way, as if searching for something. It was his habit to look questioningly, almost imploringly, at whatever or whomever his eyes were fastened on.

Early in 1961, Michael joined a team from Harvard's Peabody Museum that would live and work in the highlands of Netherlands New Guinea. A new and unimaginably novel life began for Michael on April 4, when he walked a full day to an unpatrolled and isolated part of the northeastern corner of the Baliem Valley, where he would stay for almost half a year. Entering the Baliem Valley, Michael carried a heavy load. His paraphernalia probably included the tape-recorder he had been given for his job recording sound for a film that I would eventually make about the Dani, and he also must have carried the two Nikon single-lens reflex cameras that would hang around his neck night and day for the next five months.

Michael's was a divided allegiance, to sound and to sight, and while in New Guinea he neglected neither. Though his passion was in images and not in sounds, Michael stood ready at all times to expend his formidable energy making recordings as well as photographs. Actually, he rarely stood, but was in constant, almost perpetual motion.

After six or eight weeks, Peter Matthiessen and I began to wonder what effect Michael's energy was having, photographically speaking. I could play back his recordings, but his exposed film had been sent to Cambridge to be developed and was beyond any scrutiny. Peter and I, who thought of ourselves as professionals, sometimes wondered if Michael, who was so young, might still be an amateur. So I asked for sample contact sheets of what he and the rest of us had been shooting. When they arrived, there was an ardent critique, in the course of which it became clear that, although there might be areas in need of improvement, the thrust of Michael's work was not only professional but also at times compelling. It could be said with some certainty that he was, indeed, a photographer.

There was a discernible rhythm to the Dani spectacle to which we were privileged witnesses. Moments, sometimes days, of high drama were interspersed with periods of calm or even tedium, especially during frequent and exasperating spells of rain and cold. But even in those gloomy times, Michael's desire to see and hear everything never flagged.

After almost half a year of intense involvement in the villages, gardens, and battlefields of an extraordinary community of neolithic warrior-farmers, we concluded that our sojourn with the Dani had to end. I knew that not only our lives but theirs would be different as a result of our shared experiences, but the Dani were on the verge of changes that would forever alter the cultural and physical landscape in which we had taken our separate measures.

Peter Matthiessen was the first to go, having completed a draft of his narrative *Under the Mountain Wall*. Sam Putnam returned to medical school, and Michael wanted to go home before embarking on a second, and ill-fated, journey to New Guinea, where he would visit the art-making Asmat on the shores of the Arafoera Sea. Karl Heider had steeled himself for additional months alone with the Dani, to do more anthropology. For me, there was the necessity to start working with the abundant harvest of our efforts. Most importantly, there was a film to make, which I already knew would be called *Dead Birds*. And with Karl's help I would eventually publish *Gardens of War*, a book of photographs that was to have been Michael's responsibility, but which he would never see.

Almost half a century after Michael Rockefeller met the Dani, it is clear that his eyes informed him beyond all expectations, including his own. And though he did not live to quietly consider the pictorial answers to the many questions his inquiring eyes and cameras had asked, a look at his photographs today suggests that all were instructive, many are beautiful, and a few will endure.

Robert Gardner
Cambridge, Massachusetts
July 2006

PREFACE

The Peabody Museum of Archaeology and Ethnology is home to important collections of photographs that cover great spans of time, geography, and cultural diversity. These collections have been researched and disseminated in a wide array of publications and exhibitions, both within and outside the walls of our museum. In the case of the photographs of Michael Rockefeller, we have been able to offer both an exhibition of a significant collection in the museum's Gallery 12 and their publication in this companion catalogue.

The Harvard-Peabody New Guinea Expedition generated some truly remarkable contributions in a variety of media. The film *Dead Birds*, by Robert Gardner, became an instant classic and is still widely viewed and used in teaching around the globe. The book *Gardens of War*, which, as Gardner notes in his Foreword, was originally planned to have been written by Michael, has also had a long and strong run.

The entire collection of still photographs from the expedition has been donated by the photographers and their families to the Peabody, thanks to the devoted efforts of Robert Gardner and the Peabody's registrar, Genevieve Fisher. This great body of work will provide researchers with a rich lode of information for decades to come. Michael Rockefeller's photographs are particularly captivating because of the promise they represent and the sense of intellectual adventure they embody. In large measure this owes to their aesthetic and documentary strengths, as signaled both by Gardner and by photographer Kevin Bubriski, the exhibition's curator and this volume's author. We hope that these images—some playful, others arresting, all worth pondering—will reignite an appreciation of Michael Rockefeller's accomplishments and spur a productive interest in the great wealth of resources lying untapped in museum archives.

In the fall of 2006 we celebrate both the 140th anniversary of the founding of the Peabody Museum and the 40th year of the Michael C. Rockefeller Memorial Fellowship. Exhibiting and publishing these photographs affords us the opportunity to celebrate Michael Rockefeller's life and continuing legacy in the institution that facilitated his first research trip to what was then Netherlands New Guinea in 1961.

William Fash
William and Muriel Seabury Howells Director
Peabody Museum of Archaeology and Ethnology

MICHAEL ROCKEFELLER

New Guinea Photographs, 1961

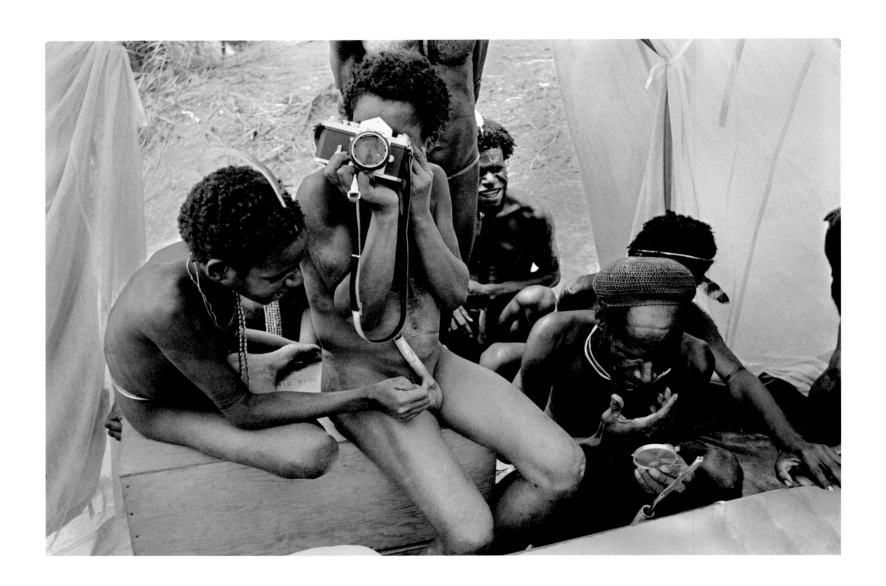

CURATOR'S REFLECTIONS
KEVIN BUBRISKI

There was a near din of clacking shutters every day and on many nights of our stay. We each had other duties, but no one could escape the photographic mania. For the others as well as for myself, making pictures was one way in which we could attempt to honor the extraordinary richness of life confronting us. It was also, I think, a way for all of us to try to create the evidence which one day might be refined by the senses into more articulate answers to the endless questions crowding our minds as we underwent the eyewitness experiences of a lifetime. During those months, one of Michael Rockefeller's most frequent expressions was "It's unbelievable."

—Robert Gardner, *Gardens of War*

In the fall of 2005, a dozen or more pale green linen binders took up a long metal shelf in Studio7Arts on Standish Street in Cambridge, Massachusetts. The faded binders were labeled *New Guinea, 1961, Black and White*, and each was marked with the roll numbers of the contact sheets contained within: 1–50, 51–100, 101–150, on up to 350. The binders were first assembled when the Harvard-Peabody New Guinea Expedition returned to Cambridge in 1961. As part of the Harvard Film Study Center archive, they have migrated over four decades from their first home in the basement of the Peabody Museum of Archaeology and Ethnology to Harvard's Carpenter Center for the Visual Arts to the top floor of Sever Hall in Harvard Yard to Robert Gardner's Standish Street studio, where I first looked through them. They are now back home, in the photographic archives of the Peabody Museum.

As I reviewed each contact sheet, I zeroed in on particular images, using the magnifier loupe to understand the details of the unfolding story. Not since the book *Gardens of War* was published in 1968 have these contact sheets been allowed to tell their tales. My eyes fell upon them nearly half a century later, and I immediately felt a strong connection with the subjects of Michael Rockefeller's photographs: the fierce warriors, the playful children, the grieving women.

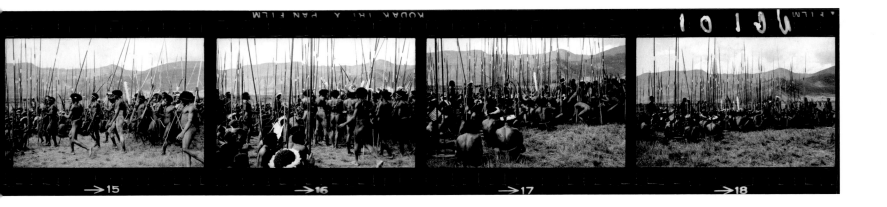

Michael Clark Rockefeller died forty-five years ago. For all of these years, most of the images he shot in New Guinea have lain dormant. For the Peabody Museum's exhibition of his work in the fall of 2006, I made enlarged photographic prints from a number of the negatives for the first time; most of the exhibited photographs are vintage prints originally made for consideration for publication in *Gardens of War*. Many striking images, unused in that book, were boxed up and put away for decades. Looking at the entirety of this large body of work, particularly the contact sheets, I began to understand Rockefeller's extraordinary journey into the Dani culture and community of highland New Guinea, and into rapport and personal connection with the men, women, and children whose faces appear in his photos.

Michael Rockefeller shot 116 rolls of 35 mm black-and-white film in the Baliem Valley in 1961, and 83 roles of 35 mm color film. I concerned myself with the black and white. I leafed through the contact sheets and made note of each image that had particular strength and visual integrity. These

memorable images appear as fresh today as they did when the moments they document unfolded.

Robert Gardner took Michael Rockefeller on the Harvard-Peabody New Guinea Expedition to serve as his soundman for the documentary footage that would become the celebrated film *Dead Birds*. But this was the beginning of the era of the Nikon 35 mm camera, a solid instrument that would become known not many years later for deflecting bullets in Vietnam, and Gardner made sure there were plenty of cameras to go around. With so many people "shooting" the Dani that season, their collective portrait is deep and rich. Rockefeller, Gardner, anthropologists Karl Heider and Jan Broekhuijse, novelist and naturalist Peter Matthiessen, medical student Samuel Putnam, and *Life* magazine photographer Eliot Elisofon all participated in filming and photographing during the expedition. Indeed, it's sometimes nearly impossible to tell which photographer took which images of the Dani in 1961. Thankfully, Michael Rockefeller took many pictures, more than four thousand frames of black-and-white film. In this body of

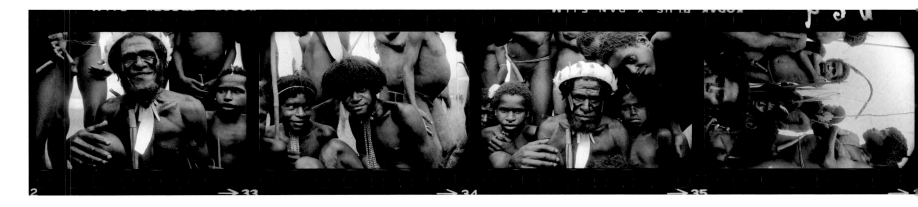

work the photographer's personal way of seeing becomes clear, along with his growing fluency in the language of the camera.

Michael knew, or learned, that a black-and-white photograph allows for a scrutiny of natural forms that is more penetrating than can be achieved in color. His black-and-white photos of the Dani are a departure from the sensory world. Gone are the blues and grays of the sky with smoke and clouds moving through it, the deep moist greens of the forest, the screaming yellows and reds of a bird's plumage as it wings through the trees. What is left is an abstraction of sky, forest, flight. Each black-and-white image is a distilled experience, a souvenir carefully selected from the continuum of life.

We have no written words from the young Michael on this expedition other than his sound logs, notes that he wrote in the field while recording sound as Gardner filmed. These logs are filled with rich details of the events he was recording. His perceptive observations are expressed in evocative language that creates compelling images and breathes life into the photographs. Although these notes rarely record the stories related to specific images, they aid our speculation about who the young explorer was at the time.

We know that Michael was able to review his photographic work in progress. Gardner and his team spent 152 days among the Dani, and halfway through this period they received contact sheets of film they had sent to Cambridge to be processed. The group critique must have made Rockefeller more conscious of what he wanted to photograph, and more self-critical, as the project continued.

In his nearly half a year in the Baliem Valley, Michael came to learn the rhythms of Dani life. And there was enough film on hand, and enough time, for him to go beyond his official mission of recording the sounds of Dani warfare and to seek out and find the in-between moments, moments that were insignificant, perhaps, in terms of major events, but meaningful in the course of daily life.

The major events among the Dani were their ritual wars with rival groups. Almost two decades ago, at Makalu Base Camp in Nepal, documentary filmmaker Peter Getzels talked with me at length

about the value he placed on working in a context of conflict when filming. This, he felt, provided the best conditions for observing a culture express itself unselfconsciously, more or less oblivious of its outside observers. In this sense, Gardner and his team found very fertile ground for cultural display among the Dani in 1961. Absorbed by warfare, grieving losses, and celebrating victories, the Dani allowed their observers to go about their work. Equally absorbed by events, the expedition members, too, often wandered into frame, showing up in production stills that allow us to look behind the camera and across the boundary between observer and observed, between us and them, revealing and complicating these categories.

Gardner told me that Michael had expressed an interest in doing a book of photographs of Dani children and their play, and we can see this sensibility emerging in his work. His camera is drawn again and again to children. Particularly moving in these photographs is the sense of mutual awareness, of friendship and trust, between the photographer and the children. Rockefeller was spending time among them, waiting for reality to unfold.

Consider the photograph of two young boys throwing spears toward a hoop impractically float-ing in air, as if held in place by the sharp sticks that pierce the space around it (see p. 30). Michael and his friend Sam Putnam often photographed together, and both delighted in this youthful war game. Gardner recalls that the two young men sometimes exchanged cameras in mid-roll, depending on who needed which type of film or focal length of lens. Putnam made a well-known photo of this event, which appeared as a double-page spread in *Gardens of War*. His is a balanced, nearly symmetrical image of boys, spears, and hoop suspended in the middle of the frame.

Michael's images of that day's sport never got much play. Perhaps this one was considered imperfect in its asymmetry, and enigmatic in its gestures. The photograph is made important, however, by the very rules it breaks: it alters our expectations of what an action shot should deliver. In so doing, it takes us from seeing comfortable and familiar surfaces to boldly expressing, "This—this culturally strange and ambiguous moment—is what it really looks like!" Lucky photographers, the likes of Josef Koudelka, for example, in the Gypsy communities of Eastern Europe, devote their waking and walking hours to finding these unexpected odd moments, out there in the world.

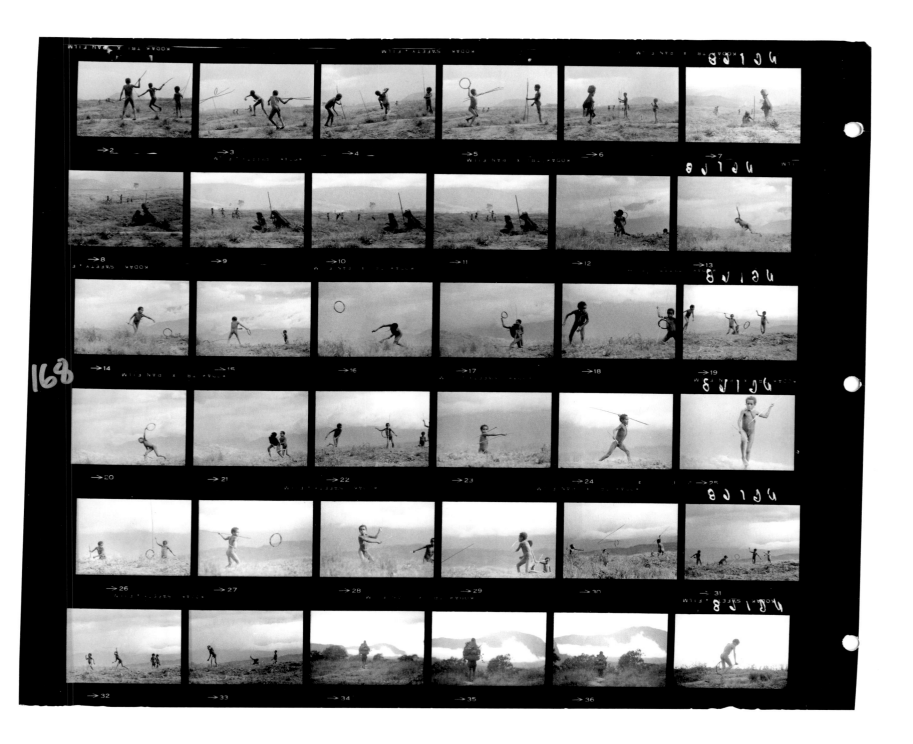

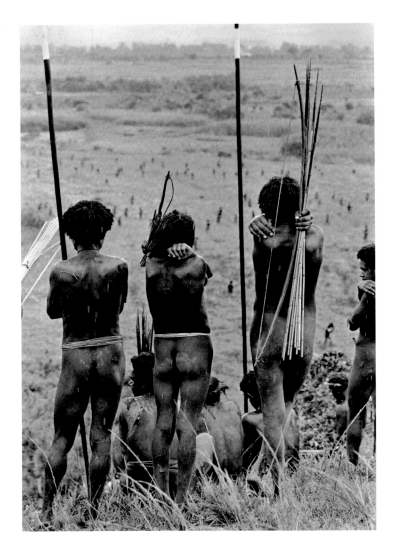

Rockefeller found many such moments. There is incredible energy in the movement of these two boys, charging with their spears toward the airborne hoop. If we could look beyond the camera's frame, we would no doubt see the young photographer charging forward with the boys, matching their steps with his own in order to stay with the drama of the moment and fill the frame with dynamic action.

Rockefeller did not yet have the professional eye or working methods of Eliot Elisofon, who in the space of just a few weeks in the New Guinea highlands was able to get what he wanted in his photographs. Elisofon found a visual vocabulary of unique gestures among the Dani and had his subjects repeat them for him. In his contact sheets we see, over and over again, young men with their arms wrapped across their own chests, hands grasping the opposite shoulders. It was a Dani gesture for maintaining bodily warmth, but in Elisofon's photographs it seems to take on greater psychological significance.

Michael did not work with this level of sophistication or premeditation. His "lucky" images are the result of his preparedness for the opportunistic moment, and his most successful photographs are those in which he was active witness to events over which he had no control.

During one rainy day of warfare, Rockefeller photographed three young men standing behind a group of warriors, intently watching a battle unfold on the plains below (left and p. 54). In this image we see the same hugging gesture that so captivated Elisofon, but here the wrapped arms convey a sense of self-preservation, of bodily self-protection, as the men face the possibility of injury or death on the battlefield. The three standing bodies mark strong vertical forms against the distant landscape, and two tall spears echo the men's lone and separate shapes. Strong white lines of waistbands bisect two of the otherwise naked bodies, while the clasped bow and arrows of the figure on the right are silhouetted against the distant landscape and contrast starkly with the young man's dark back. Short, vertical white streaks across the frame are falling drops of

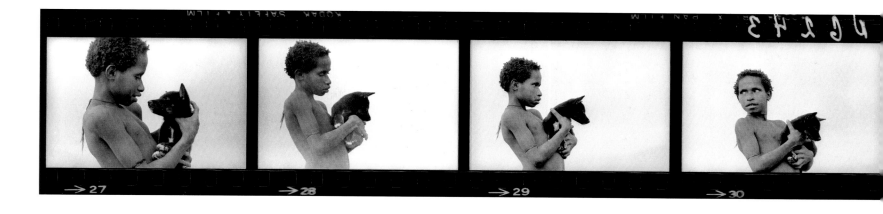

rain, frozen by the camera. The three young men are not thinking about the photographer behind them or posing for him; their concentration is wholly focused on the scene below.

As we appreciate the beauty of images such as this, it is interesting to reflect on the only published statement we have from Michael about his photographic work among the Dani. In the volume *The Asmat of New Guinea: The Journal of Michael Clark Rockefeller*, compiled after Michael's death by Adrian Gerbrands, Michael writes,

> The Asmat trip was equal to my wildest dreams. I was very quickly elevated from a slight case of depression deriving from considerable disappoint ment over the first results of my photographic efforts in the Baliem. In retrospect, my approach to the problem of photographing the extraordinary life we have found among the [Dani] was quite naive. Especially in the fact that I chose to follow my own inexperienced instincts without once seriously attempting to make use of thoughts based on long experience from Bob Gardner or Peter Matthiessen. … Photography like other artistic mediums requires a very particular

combination of talents, and I now know that an eye sensitive to aesthetics by itself assures little.

Michael's critical appraisal of his own photographic efforts among the Dani expresses an honest humility. Now, decades later, we have a greater appreciation than he did of the aesthetic genius of his sensitive eye. Technology and the methods of documentation may shift over the decades, but there really are no hard-and-fast rules by which we can measure success in the arts. When a gifted observer like Michael Rockefeller finds a personal way of seeing and understanding the visual world, it is a gift that endures.

At a certain point, Michael seems to have lost faith in his own response to the "unbelievable" world around him, but his photographs are witness to and evidence of his sensitive observations while he was documenting that world. A few short months later, by the time he wrote his Asmat journal, Rockefeller had become self-conscious about photographic expectations and techniques. His photographs in *The Asmat of New Guinea* are straightforward documentations of dugout canoe journeys and portraits of wood-carvers and their

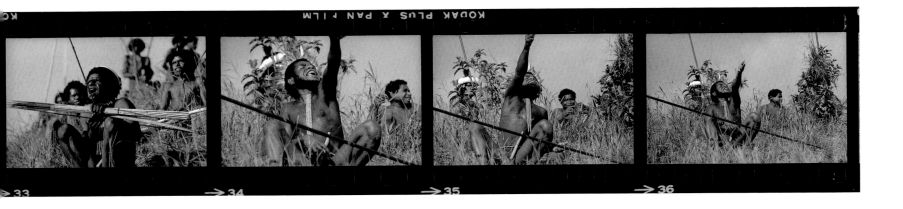

artworks in the Asmat villages he visited. The first unfiltered gaze and visual magic of his time with the Dani is hard to discover in these photographs. In search of images that supported his curatorial mission of collecting Asmat art, Michael may have momentarily shut the innocent eye that in his Dani images explored all photographic possibilities with such curiosity.

Robert Capa famously captured on film the moment a soldier was shot during the Spanish Civil War, gun flying from his hand as the impact of the bullet slammed his body. Rockefeller's photo of a solitary warrior, caught midair as he launches himself a full foot or more off the grass-covered hillside (at right and p. 53), recalls Capa's classic image of mortality. But Rockefeller's subject has been catapulted skyward by his own exuberance. The dynamism of elbows and knees is an important element of the composition of many of Michael's black-and-white images, and here we see an exaggerated, almost spring-loaded *contrapposto* of body and limbs.

The bodies revealed by Rockefeller's camera recall images from the long history of human art, from the eight-thousand-year-old cave paintings of hunters and herdsmen on Algeria's Tassili Plateau to ancient Greek statues and vase paintings of athletes and warriors to Michelangelo's *David*. In nakedness we see revealed the full gestural quality of the body as it appears when living in close proximity with nature. The body as presented in these Dani photographs plays on our visual memory, and at the same time exposes new and unfamiliar ways of being.

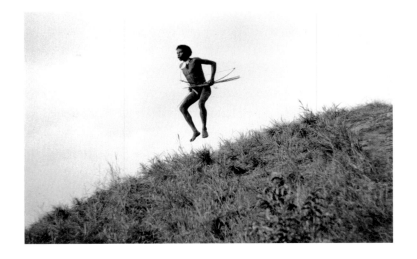

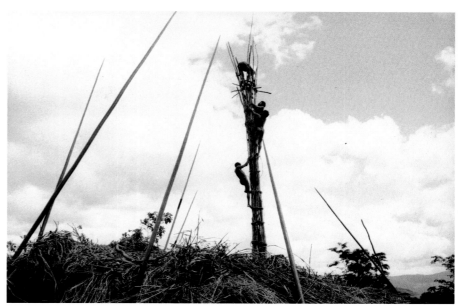

In a photograph of men around a fire pit (see p. 80), harsh sunlight silhouettes arms, legs, and torsos, and the long poles that the men are poking into the smoking embers. The repetition of elements, of shadows and silhouettes, creates a dynamic balance that appears to expand and contract at the same time. Repetition is used to good effect again in a photograph of women performing a victory dance (see p. 78). The legs of the two women in the foreground are bent at identical angles, their left hands with mutilated fingers are raised aloft in the same gesture, and the lines of their spears nearly intersect to form two sides of a large encompassing triangle. Behind them, a third figure presents a mirror image of the primary figure in the composition.

The sense of composition, of deliberate if intuitive framing, is strong in Rockefeller's work. In one image of the ubiquitous watchtowers (above), the warriors' spears aim toward the tower at sharp diagonals, while the young man ascending the slender construct of poles is framed against large cumulus clouds that break up the sky. Watchtowers were everywhere in the territory of the Dani, and they are everywhere in the photographs of the expedition. Most of these photos convey the lonely and looming presence of the towers, but few have this dramatic dynamism of activity surrounding them. As in so many of Rockefeller's photographs, it is the context of human interaction that moves the viewer.

In *Gardens of War* there is an extraordinary sequence of wide-lens, medium-format Rolleiflex images taken by Karl Heider. They show a wounded young warrior being carried away at a run from the line of battle by several older warriors, and they graphically reveal the chaos of battle and the intense pain incised on the youth's face. On the following page is Michael's complex portrayal of the same warrior. Rockefeller's telephoto lens brings the viewer into the very center of the cluster of men who are performing battlefield surgery.

Viewed up close, the wounded fighter appears a mere boy (see pp. 12 and 61). His eyes are shut in pain, resignation, and shock, and his head rests on the shoulder of an older, bearded warrior, who gently cradles the youth's chest. Another warrior's hands delicately support his head, and a third seasoned fighter concentrates all his energies on extricating a broken arrow from the youth's chest. The frame is filled with the tenderness of brotherly and fatherly care. We have seen essentially the same image many times in many cultures: in Eugene Smith's photographs of World War II, in the Vietnam War images

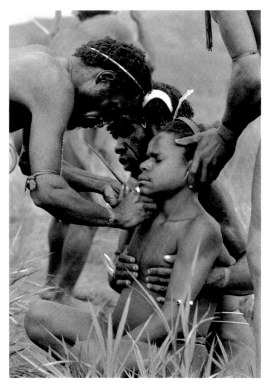

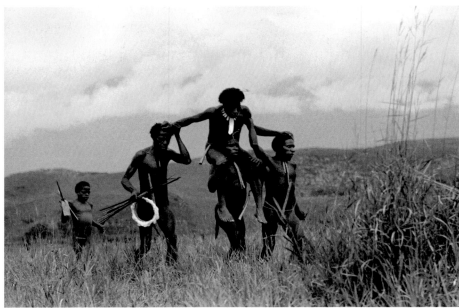

of David Douglas Duncan and Philip Jones Griffiths, in the Bosnian War scenes shot by Gilles Peress.

Another of Rockefeller's photos (above right and p. 60) is a revelatory presentation of a moment repeated throughout human history, as men come to the aid of a fallen comrade. Here the wounded man straddles the shoulders of one companion, his hands on the heads of two others who support and balance his arms. Each adult face is heavy with worry and foreboding. By contrast, the child-warrior who follows close behind appears almost oblivious to the seriousness of the moment.

The photographic record of the Peabody expedition focuses on Dani men and their activities. The relative absence of women results from both the

interests of the researchers and the fact that they themselves were male, with limited access to the lives of Dani women. In Michael's photographs, women appear prominently only at times of grief and victory, suffering or celebrating male activities. In one particularly disquieting image (opposite left and p. 73), two very young girls sit on the ground in front of the wooden wall of a Dani home. Older women, likely their mothers, sit with them, while a third peers at the photographer from the doorway of the house. The two little girls hold up their right hands, which are bandaged with leaves and vines. Their fingers have been amputated with a stone ax to appease the ghosts, who have been unsettled by the battlefield death of a family member. These are the stubs of

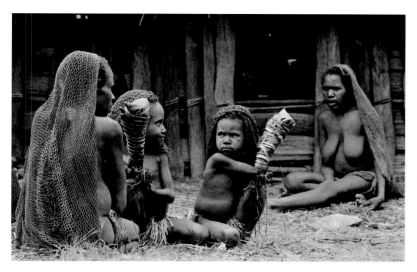

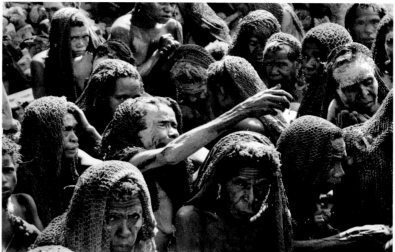

fingers we see in other pictures of Dani women, fingers sacrificed to secure the safety of the people.

In a photo of women grieving (above right and p. 71), bright sunlight illuminates the tops of the bowed heads and the extended arm of the central figure, just as it hides most of the clay-streaked faces in a veil of shadow. The gesture of the outstretched, withered arm, covered with the white clay of mourning, breaks the uniformity of grief expressed in the slumped postures of the other women huddled within the frame. And this hand, too, shows amputated fingers.

Among these Dani women there is none of the bodily adornment or concern for visual display that we see in the images of the men, with their feathered headdresses, horn neck-rings, and elaborate penis sheaths made of dried gourds. Dani women haul firewood, harvest food from the fields, carry and

nurture their young through pregnancy, infancy, and early childhood. The punishing harshness of their lives is nowhere more evident than in this image of the awful, final chore of grieving for their boys and men whose lives have been lost in warfare.

Even a women's victory dance appears a joyless affair (p. 14 left and p. 77). The women's listless arms are raised as if the gesture is demanded of them, and the few faces we can see are tired and haggard, with eyes downcast. The camera documents a ritual carried out more as a chore or duty than as the exuberant act of celebration one might expect. There is no adornment, and no apparent rejoicing. Hands hang from bent wrists, and mutilated fingers are again apparent on every hand in sight.

And yet part of Michael Rockefeller's genius as he worked in New Guinea was his ability not only to capture the harsh and brutal realities of a life

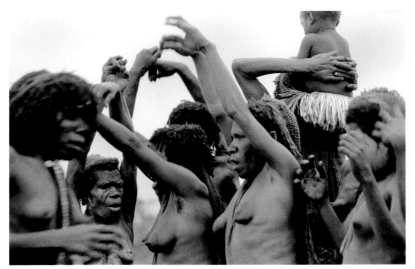 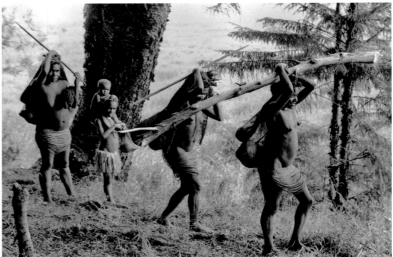

governed by warfare and the fear of ghosts, but also to establish a rapport that allowed him to participate in more intimate and lighthearted moments. In a rare photo of women engaged in everyday tasks (above right and p. 21), we see a group of women and girls on their way to gather salt. A woman in the foreground balances a log on her head, probably firewood, and she and the others carry nets filled with large sweet potatoes. Everyone in the image appears to be aware of the photographer and his camera. A young girl is perfectly framed by a wide, dark tree trunk, and the round-faced toddler on her shoulders has caught Rockefeller's eye. Two of the women flash wide smiles at the photographer as they continue striding along the path; the young girl with toddler and a woman behind her have stopped in their tracks to gaze at him.

There may be hazards in trying to read too much into a single photograph. Almost always, a successful image is a balance of the photographer's intention and the happenstance of the moment. In this photo, we see a particularly comfortable balance of agricultural plain and forest, of Dani women and the surrounding vegetation. The photographer and his subjects are also in balance, as if they have just met along the path as they go about their daily tasks: the women carrying home a harvest of sweet potatoes and firewood, the photographer capturing daily life on film. The smiles and attentive gazes of the Dani engage the photographer and his subjects in a visual conversation, a portrait of connectedness. As viewers of the image, we too are brought into this web of interconnection.

In a particularly relaxed and intimate photograph (see p. 2), a group of Dani men and boys crowds into one of the expedition's tents with Michael. The photo centers on a boy who sits on a wooden expedition crate and playfully points a

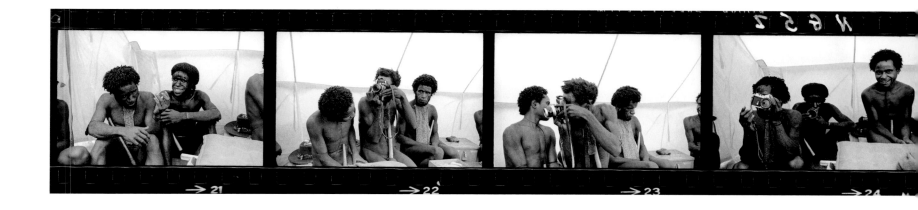

Nikon camera directly back at Rockefeller. Seated next to the young Dani photographer is another boy, who appears to be adjusting his friend's penis sheath. An older Dani warrior, sitting on the floor, studies himself in a mirror and applies face paint. At least three other warriors watch from outside the tent's open flaps. Other than the boy with the camera, no one appears to take any notice of Michael's presence in their midst. In this moment, the fierceness of the warrior culture has dissipated, replaced by the warmth of mutual trust, curiosity, and friendship between Michael Rockefeller and his Dani subjects, whose subject he has also, fittingly, become.

As photographers, we often wonder who will look at our images after we are gone. What will be the destiny of our work? How will it be understood and perceived? In selecting photographs for this publication, it has been my responsibility to present a set of images that can fairly represent the larger body of Michael Rockefeller's work. The process has been by no means scientific or analytical; it has been a personal journey through Michael's photographs, trying to see what he saw through his camera's eye. I have chosen those images that I feel best express his developing vision as a documentary photographer, an artist and observer who was able to convey ethnographic information in strong visual statements that imprint themselves on our visual memory. Many equally stunning images have been left out.

This is not the final word on Michael Rockefeller's photography. It is, rather, but a step along the way of rediscovering this great body of work, work as fresh and startling today as it was when it was made in 1961. As we marvel at his emerging personal way of seeing the Dani people of New Guinea, our imaginations are haunted by thoughts of who Michael Rockefeller would have become in the years to come, and what other remarkable images might have been part of his larger legacy.

How peaceful the valley looked that first morning. Impeccable gardens covered the slopes coming down to the Baliem. From what I could see, the valley was a vast and fertile farm where diligence played an unusually important role.

For this reason it was doubly shocking to see, a mile or so in front of the villages, indisputable evidence of hostility—watchtowers of lashed poles standing along an irregular frontier as far as the eye could see. Clearly the people we were watching were not only farmers, but warriors.

—Robert Gardner

Two men singing as they work with heavy digging sticks. The thumping is that of a digging stick being driven into the ground in order to loosen it in preparation for the planting of potatoes . . . Planting to be done by the women. The men only involve themselves in the heaviest form of gardening . . . They hum an *etai* tune as they work.

—Michael Rockefeller, June 3, 1961

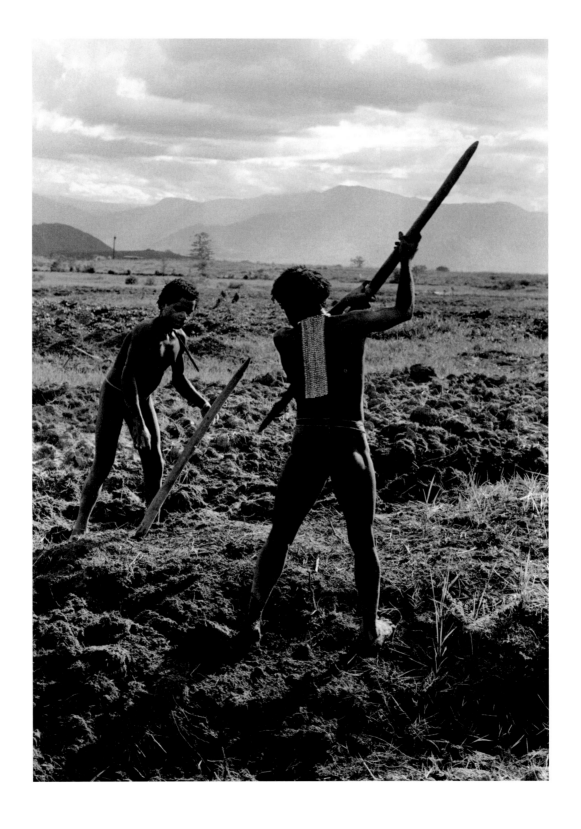

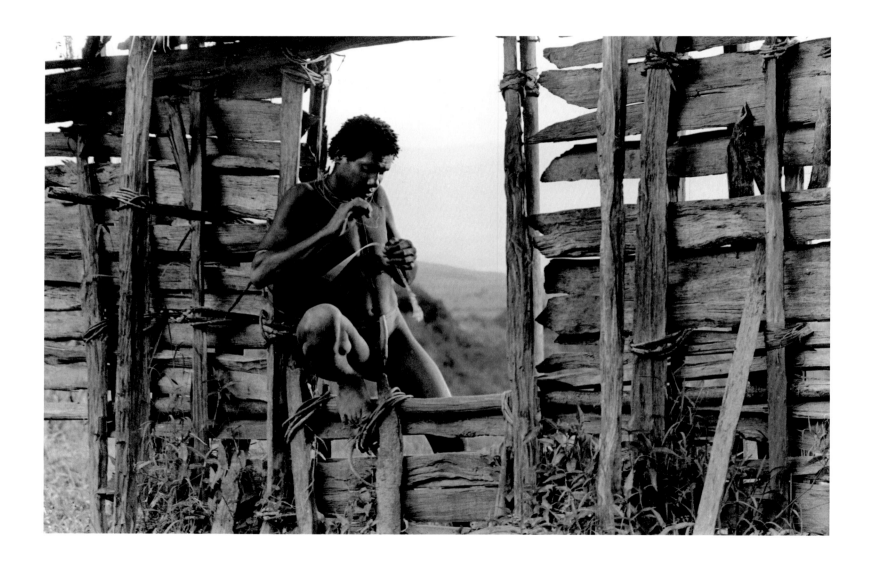

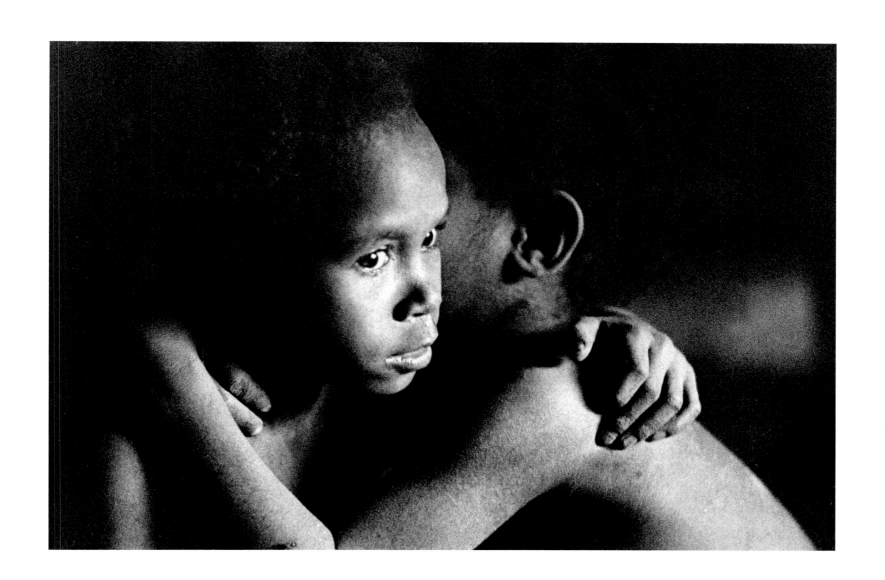

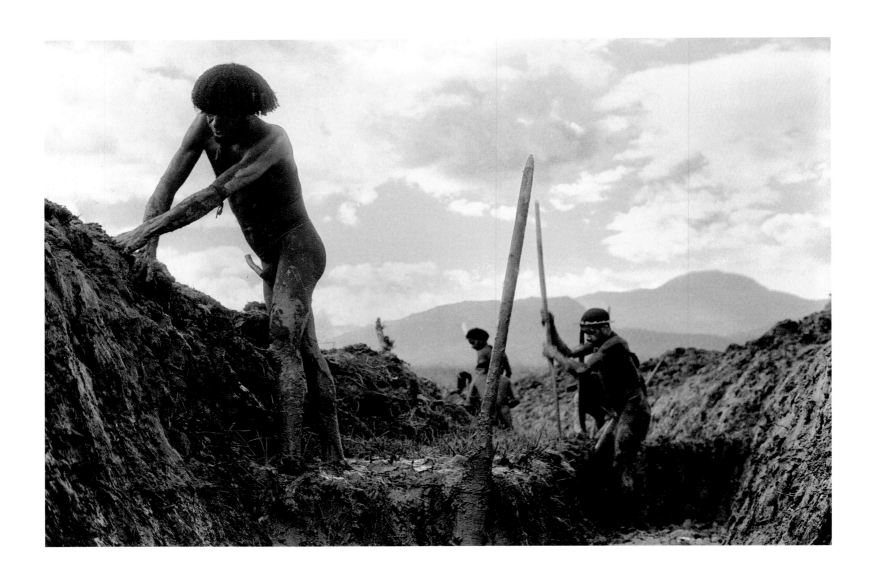

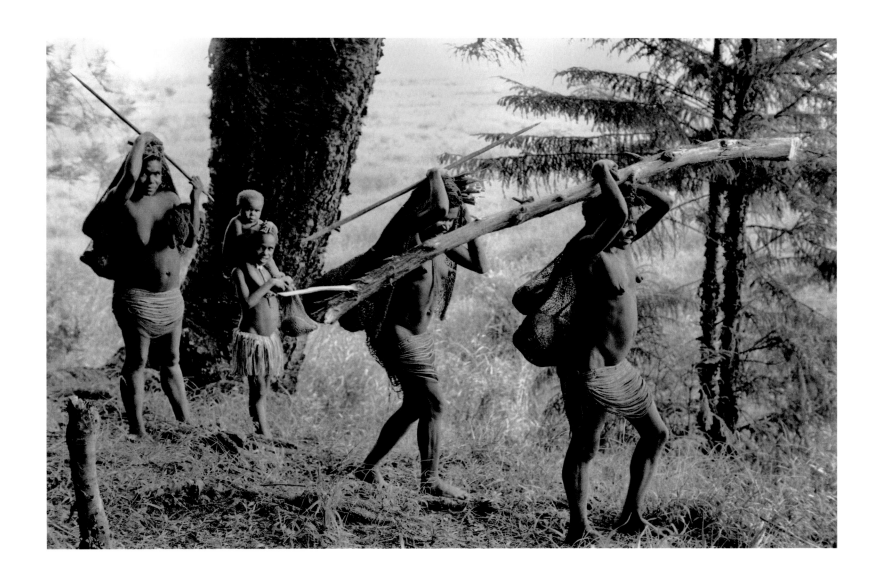

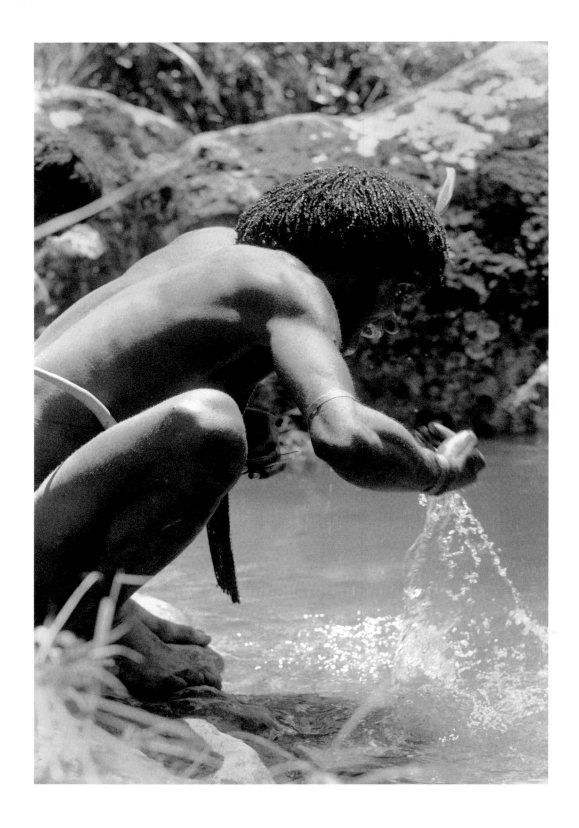

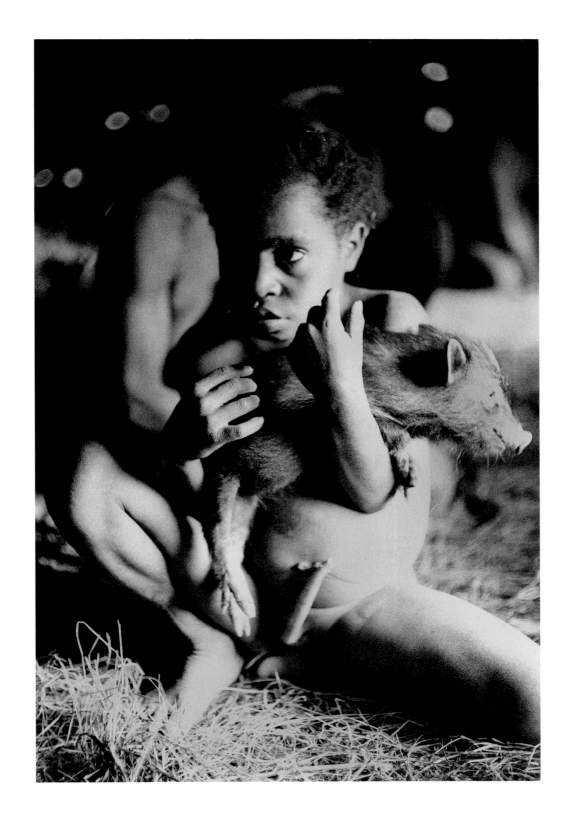

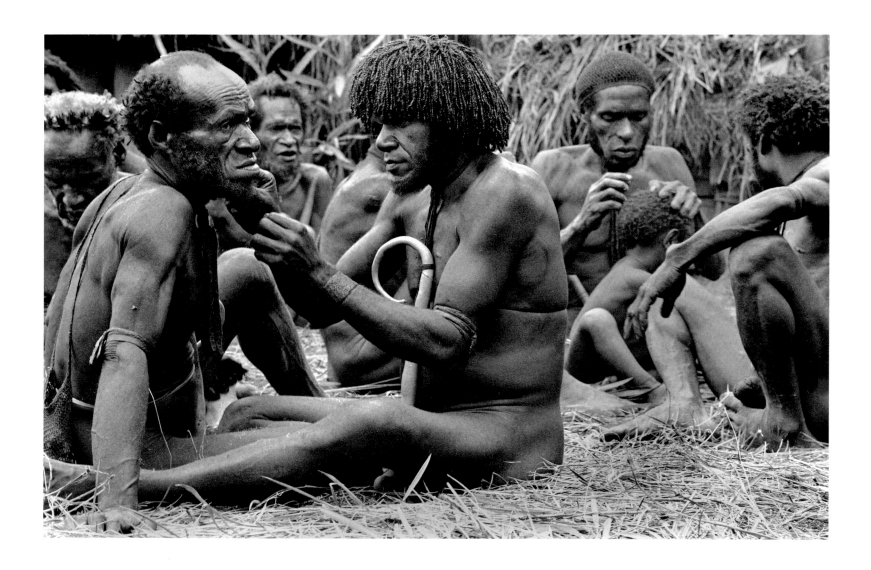

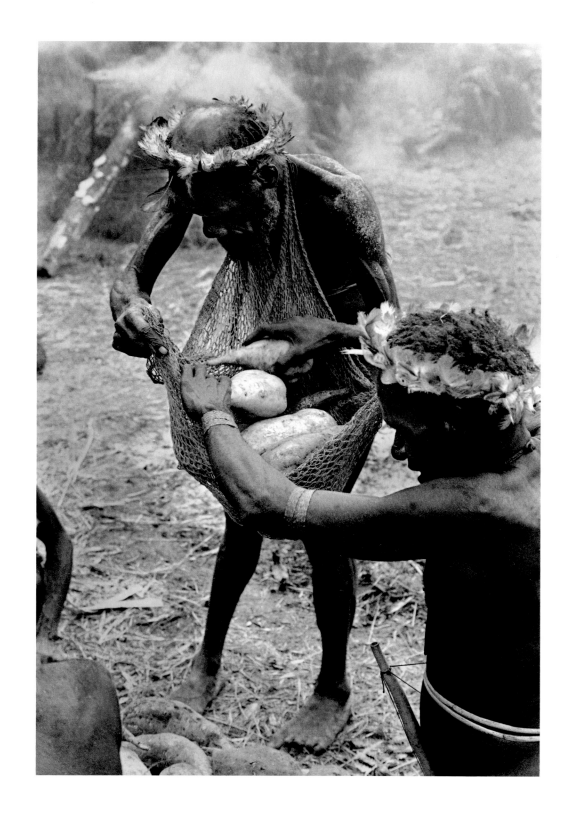

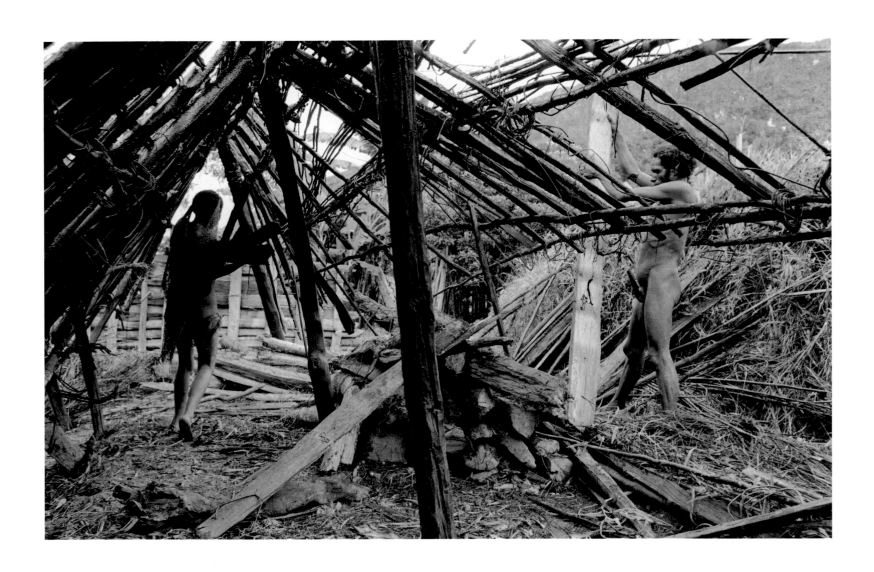

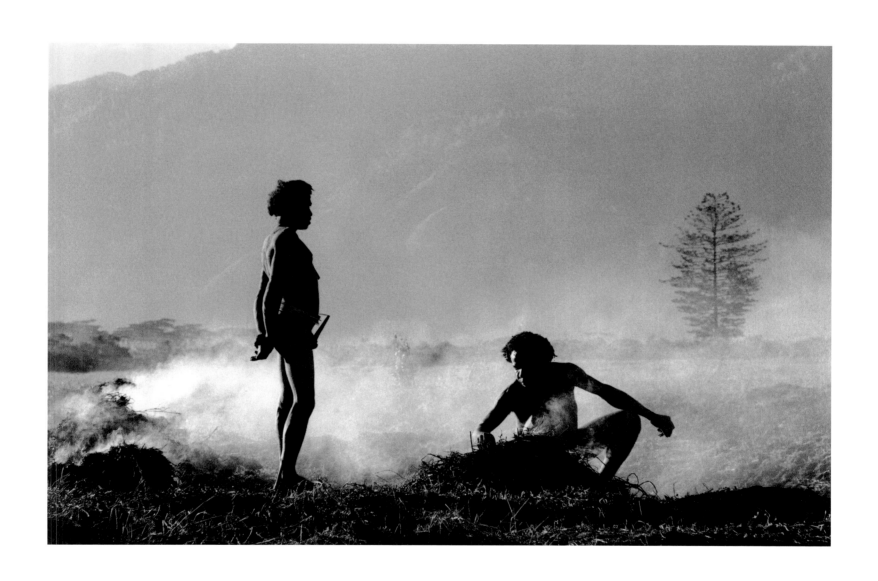

The *jegerugui*, the children of the Dani, can afford to lose no time growing up. When the boys are four or five they begin to join older boys in *weem yeles*, the war games that help them prepare to take part in formal warfare. The girls, who are not as free as the boys, spend less time at play. Long before boys begin to behave like men, girls are little women—planting, cultivating, cooking. Still, while they are children, they are not without some childish pleasures.

—*Robert Gardner*

Boys playing war . . . Their object was to simulate the kind of war in which their fathers indulged, as closely as possible. The charges, stalking, retreats, even the spears (made from the cane found in the field) were real in miniature. The sounds correspond to the progress of the battle, whether it be the swish of feet running through the field, the whoops of triumph occurring when an enemy is hit, or the shouts stimulated by a mass attack.

—*Michael Rockefeller, April 19, 1961*

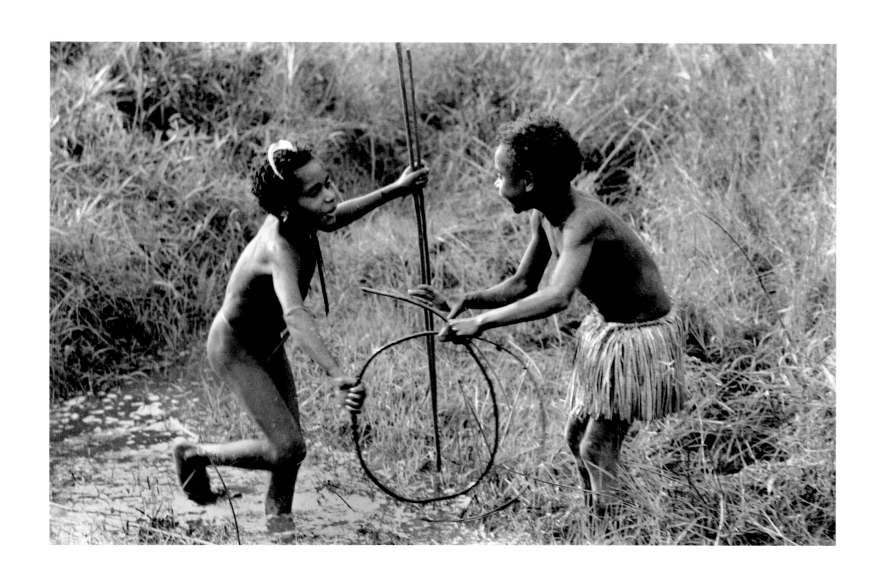

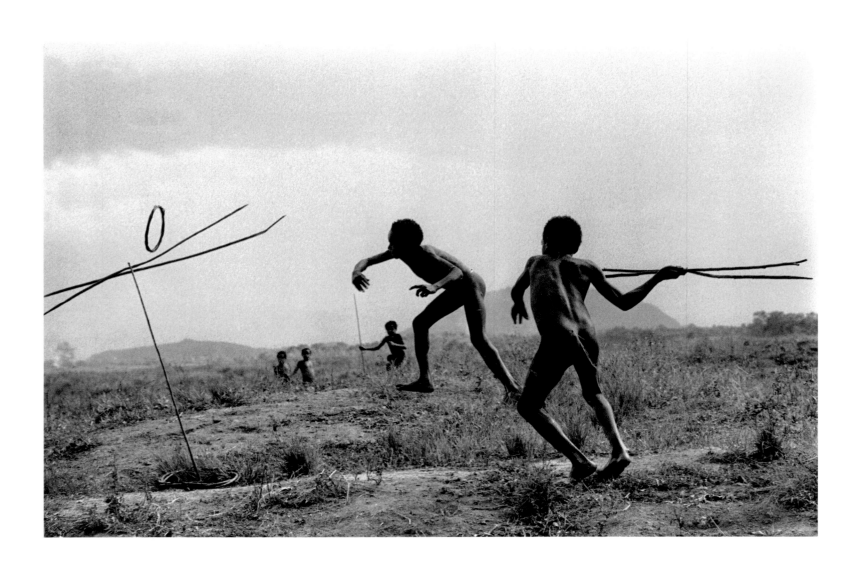

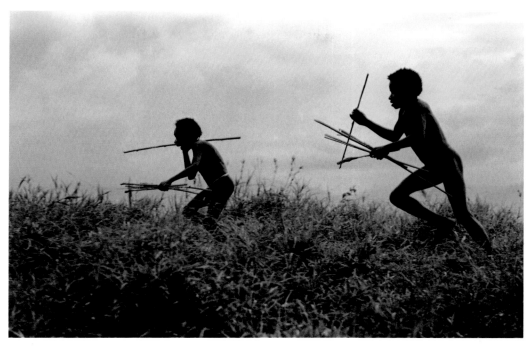

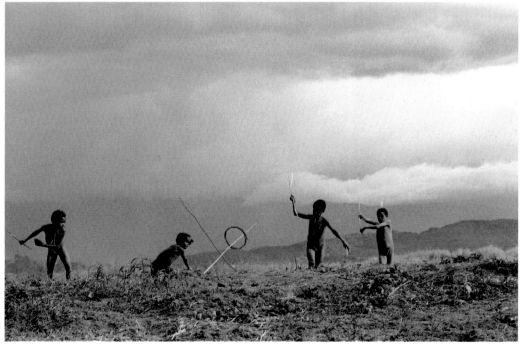

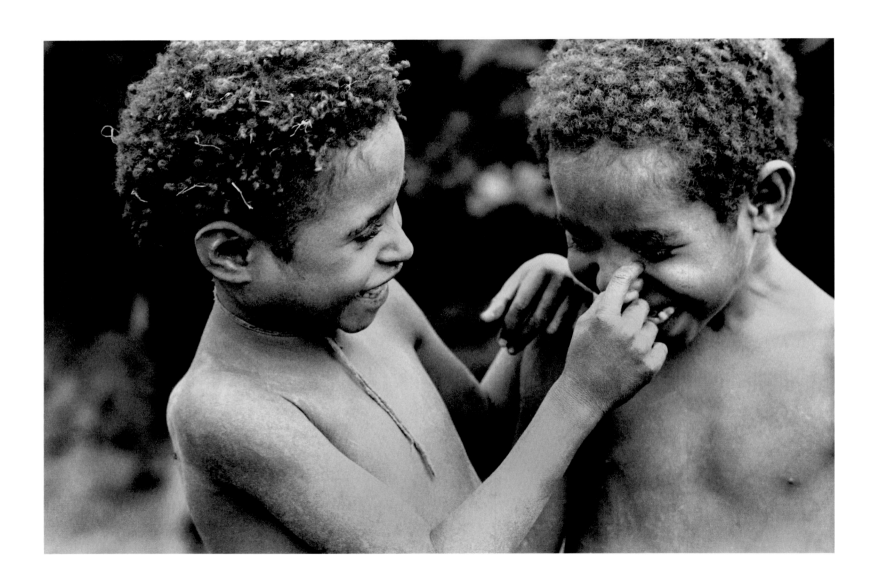

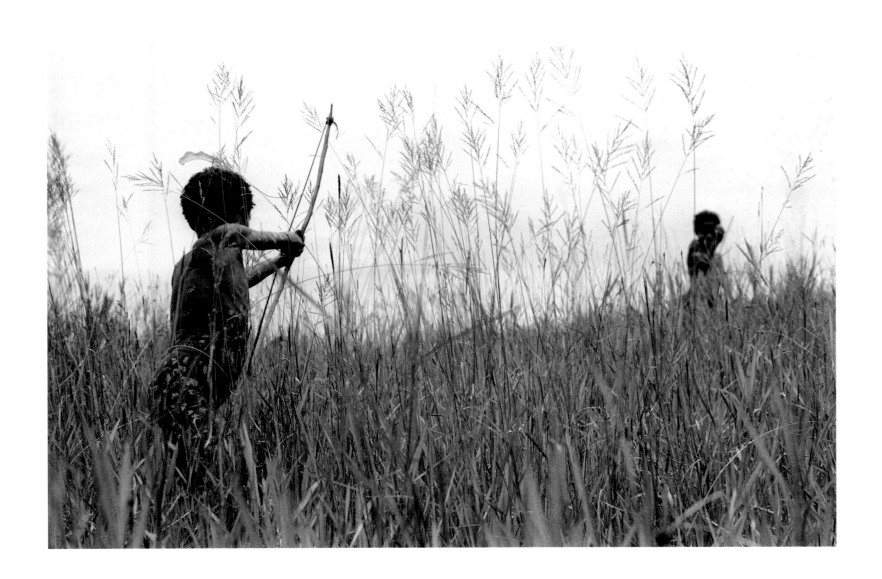

The children learn by watching and listening. They are schooled by direct contact with virtually all the major events of life by the time they are five years old. They know about magic, death, war, gardening, house building, and pig keeping by having experienced them. Very little is hidden from children.

—*Robert Gardner*

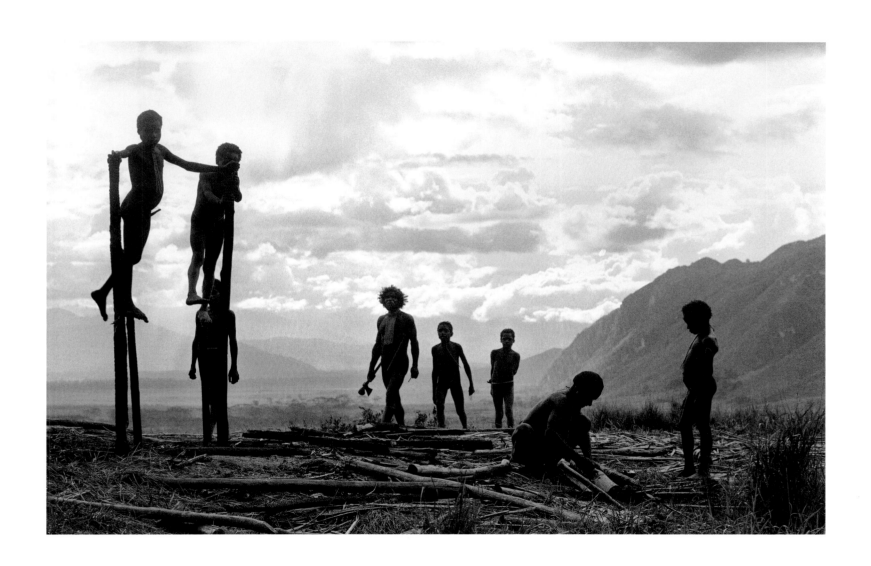

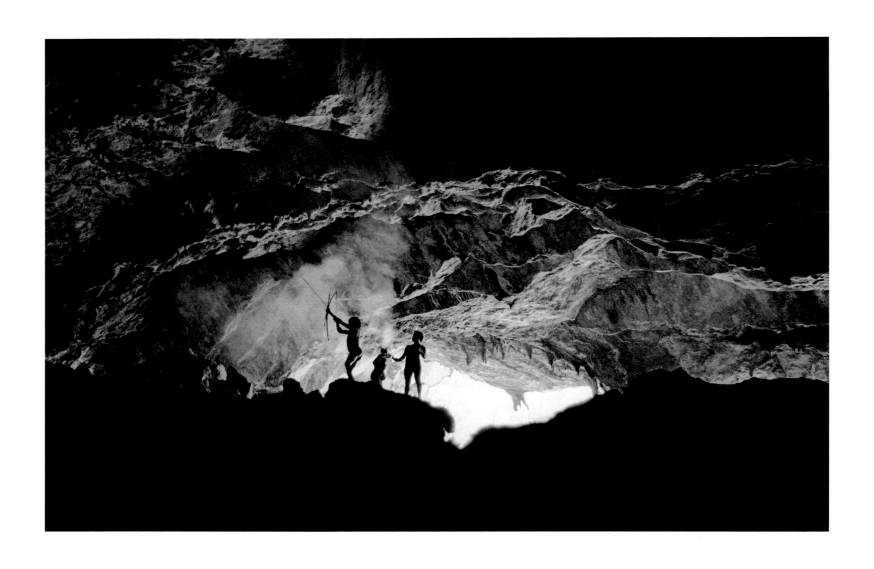

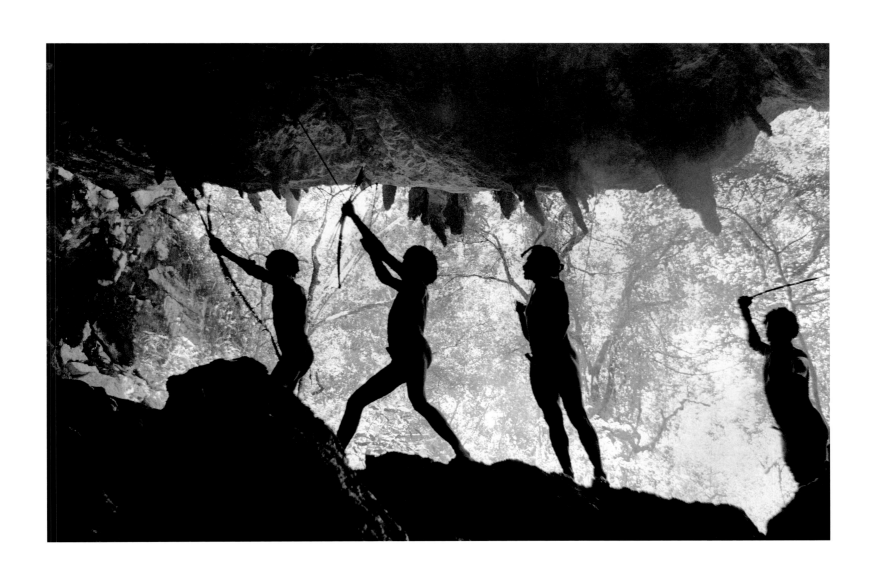

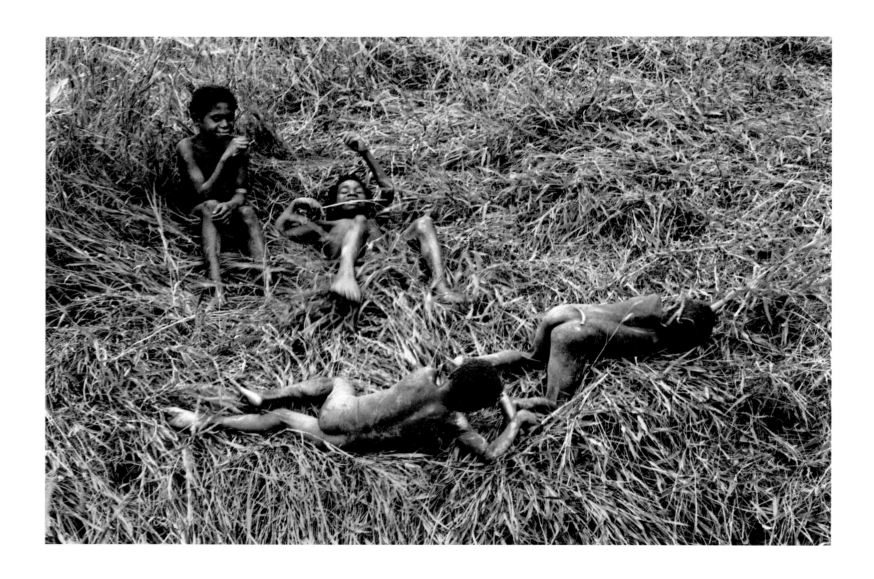

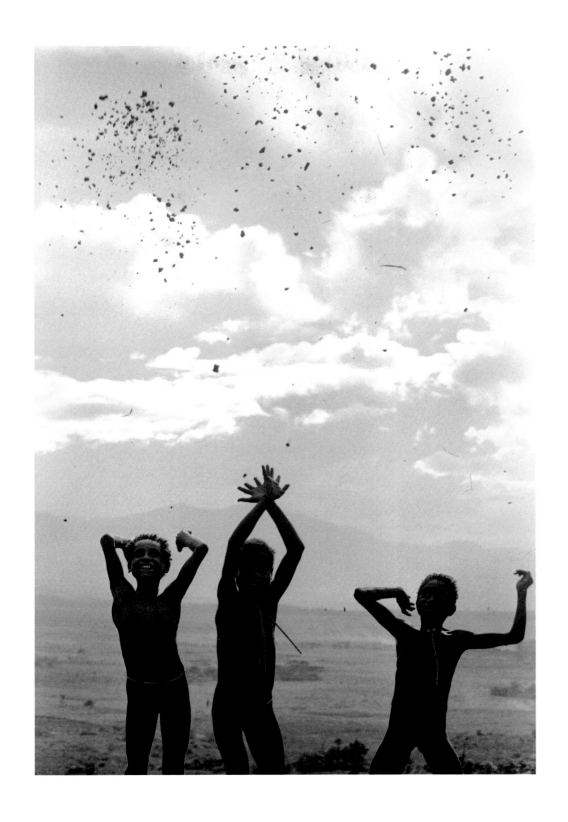

The Dani of the Grand Valley are divided into some dozen alliances, each a potential enemy of the others. They are separated by a frontier guarded on both sides of a no-man's–land by watchtowers, and lookouts man these from dawn to dusk.

—*Robert Gardner*

The beginning of the empty sensation of evening. There is a casualness in the air which breeds the feeling among the Willihiman-Wallalua that the Wittaia are no longer a threat. Then several outbursts of taunting, the Willihiman-Wallalua and Kosi-Alua jeering at the Wittaia—a similar display had brought the Wittaia to the devastating attack in the last war.

—*Michael Rockefeller, June 7, 1961*

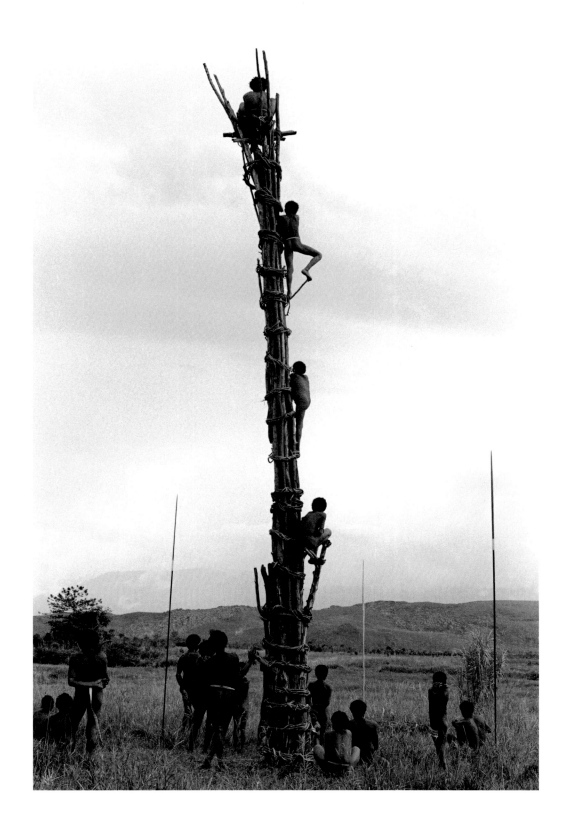

To be aware of *what* one's enemies are apt to do in order to kill is not necessarily to know *when*. On their way to the watchtowers in the morning, men are especially alert for any unusual footprints or trampled grass. They also pay close attention to the birds, for any absence from their customary thickets or groves may be a silent warning of intruders. When approaching danger areas, men walk quietly, never talking, because an enemy ambush must be heard the moment it is unleashed. The few seconds of silence may mean the difference between life and death.

—Robert Gardner

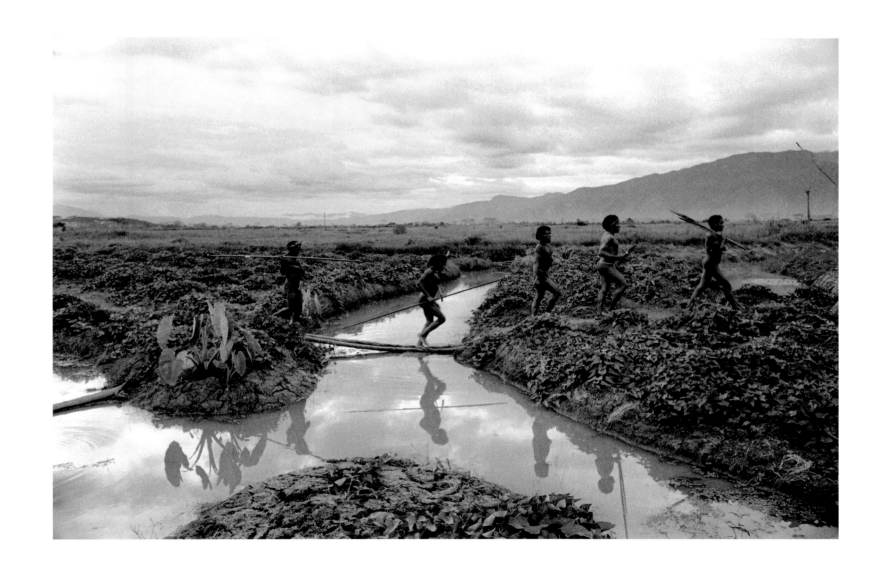

No phenomenon, either real or imagined, is of greater significance to Dani life than their belief in ghosts. When a member of one warring faction has been killed by his enemy, there is set in motion an elaborate sequence of events whose purpose is to kill a person on the offending side. It is axiomatic that such a ghost will not rest until the living avenge it.

When a war leader decides to call a battle, a band of his men will go early in the morning to the frontier and challenge the enemy by shouting across the no-man's–land.

—*Robert Gardner*

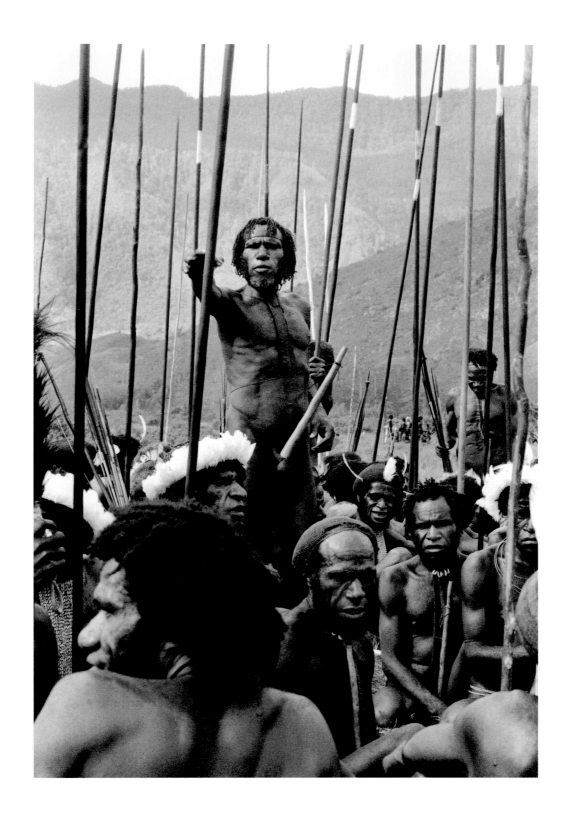

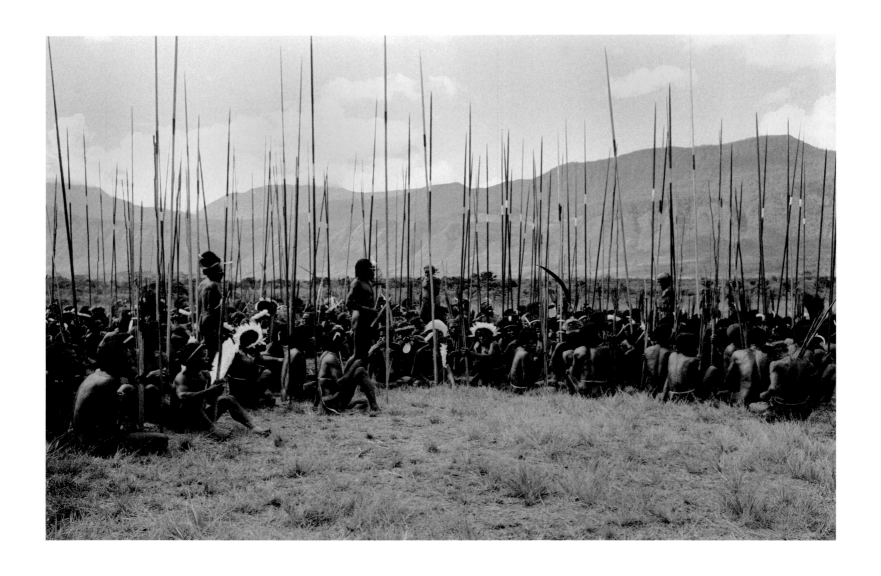

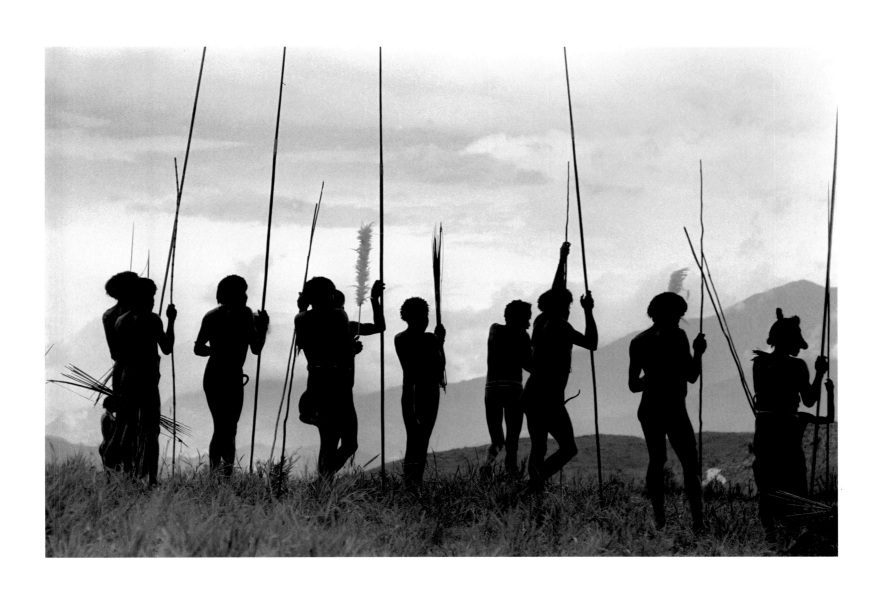

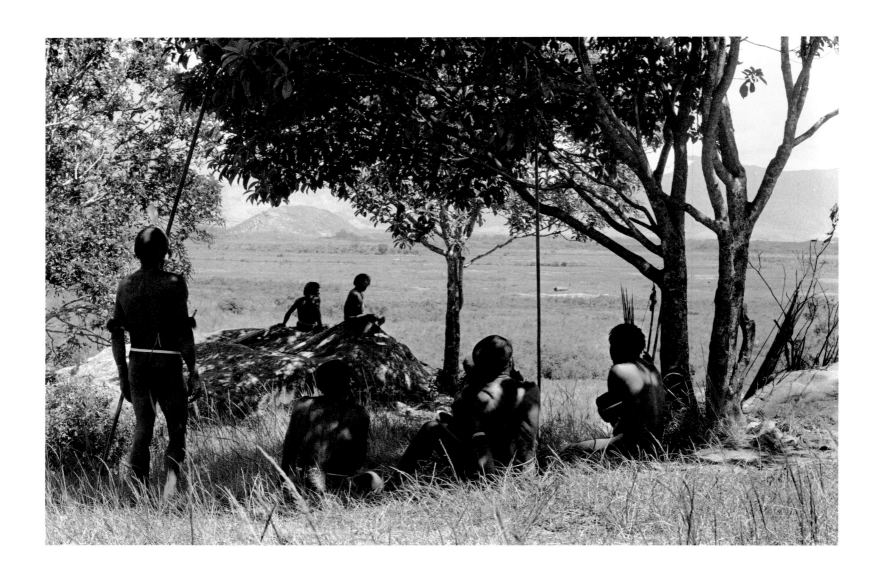

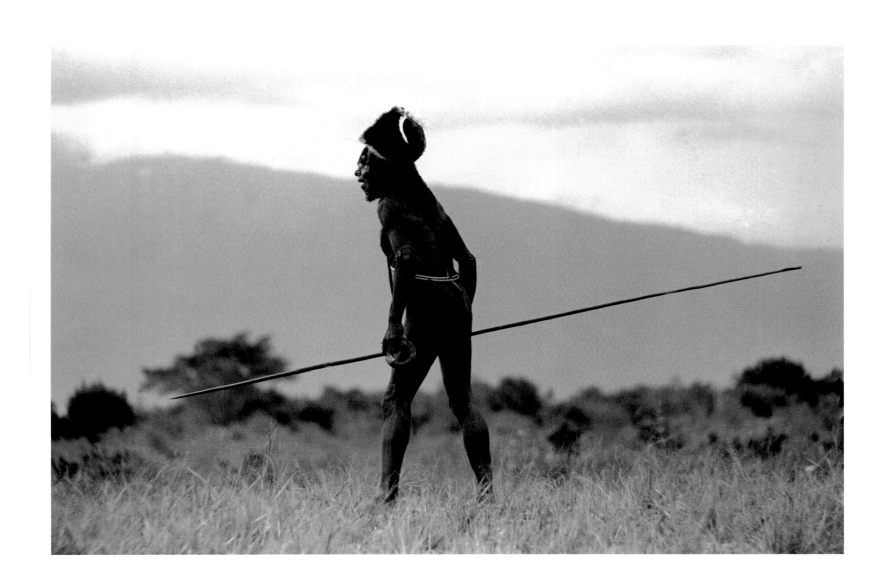

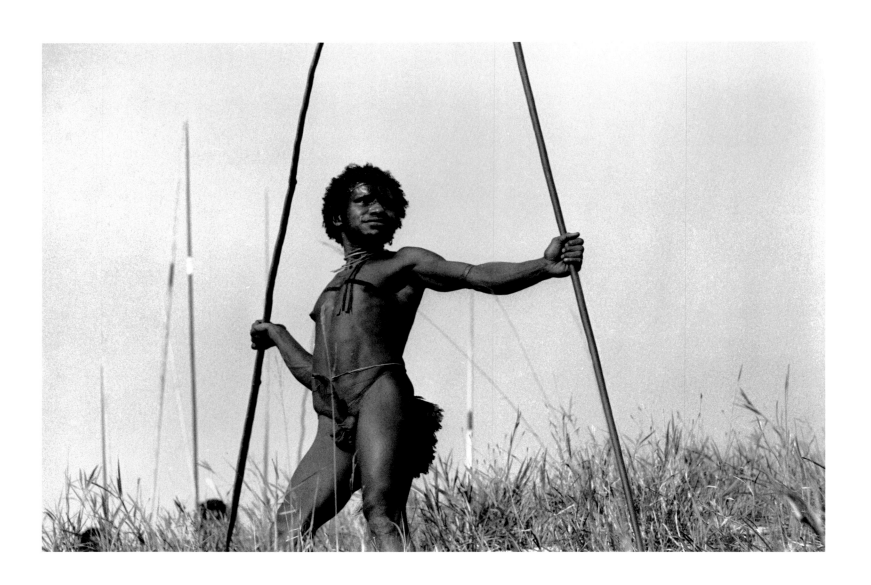

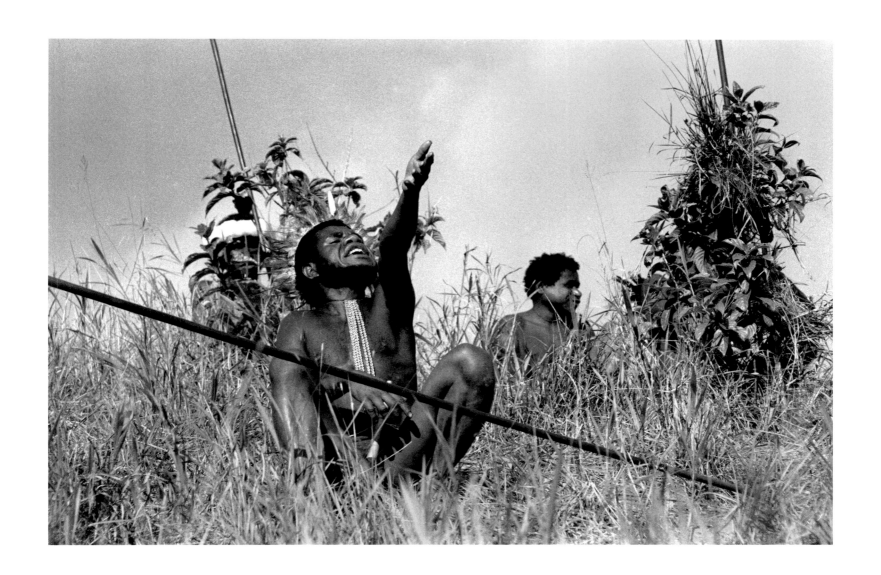

All Dani men are professional fighters. They have been trained since learning how to walk in all the techniques of war. During battle a mood of silent but excited expectation pervades all ranks. The day will bring the pleasures of fighting to several hundred on both sides, momentary terror for the handful who will feel the sudden pain of an enemy arrow, and, rarely, the unmentionable shock of death.

—Robert Gardner

The battle begins again, this time reaching a new height—frantic yelling of instructions—the rise and fall of the yelling. The wildest moment of all came with the culminating drive by the Wittaia. They swept our warriors entirely off the Warabara. For a moment before running myself, I taped the warriors as they streamed past me . . . Marvelous whooping between the two sides . . .

—Michael Rockefeller, May 26, 1961

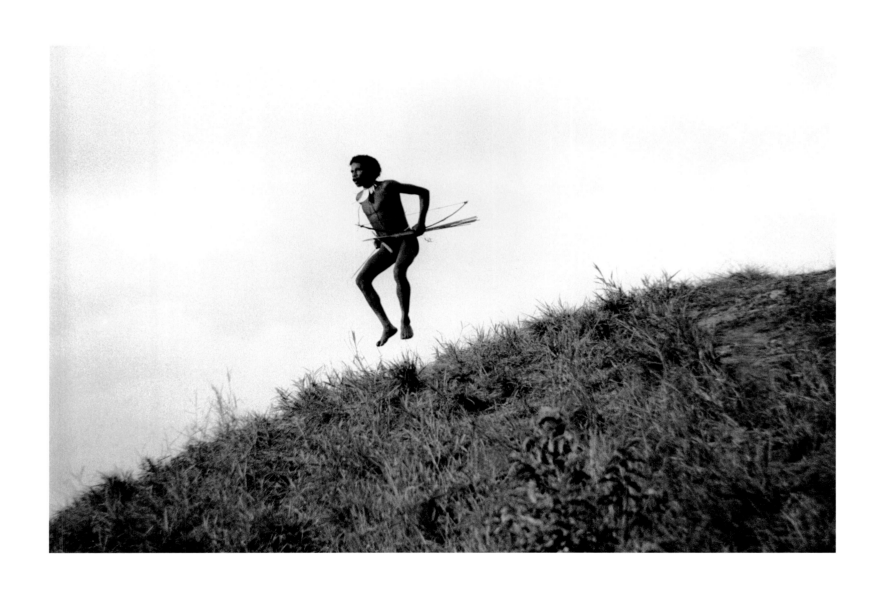

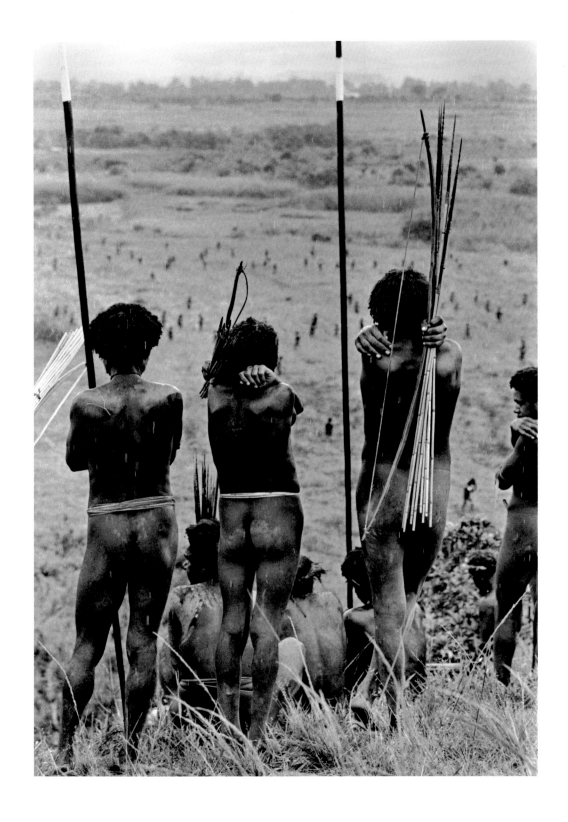

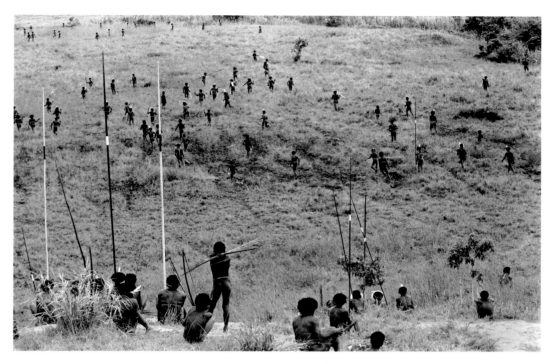

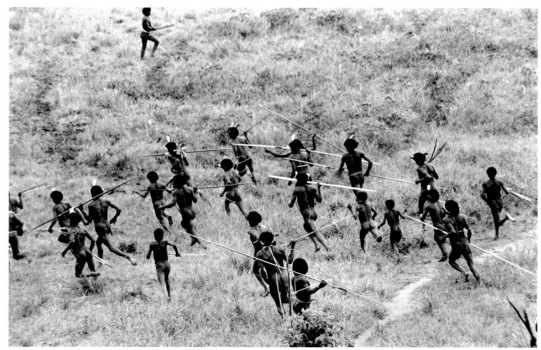

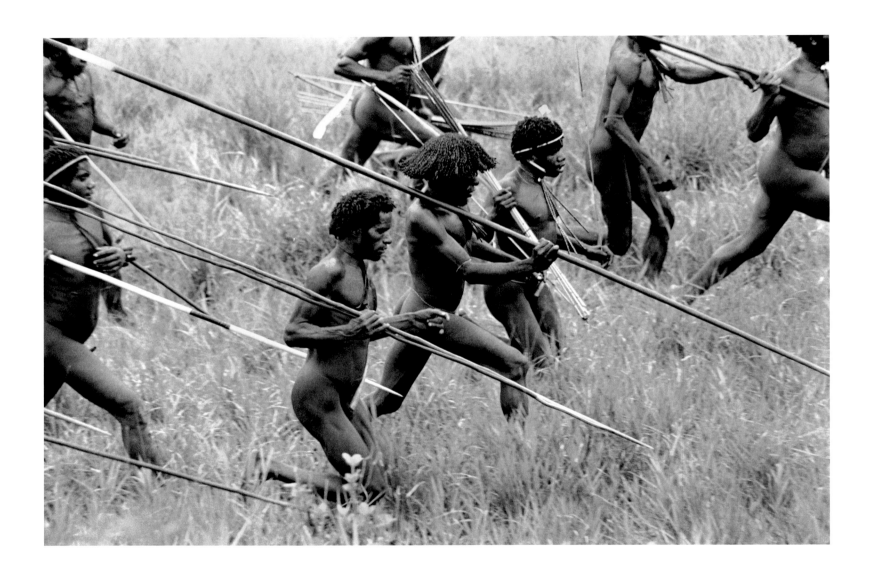

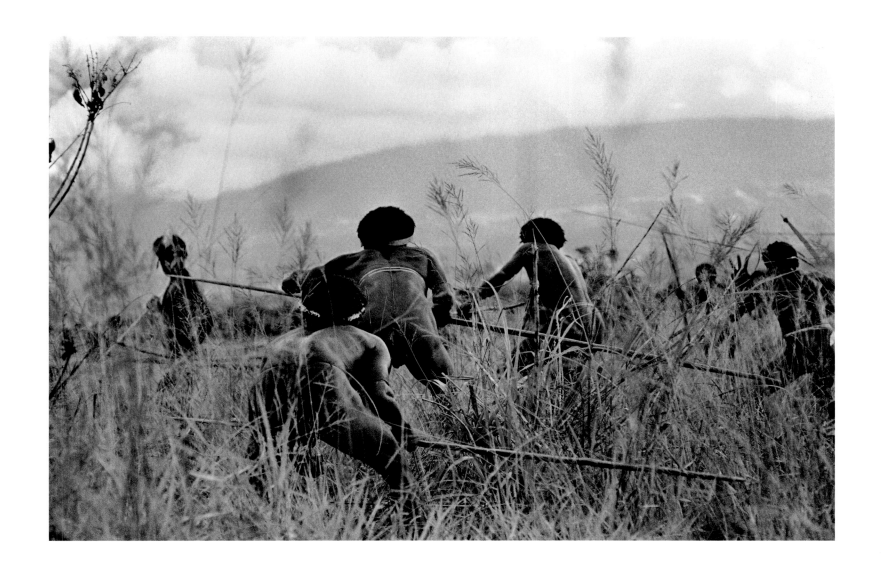

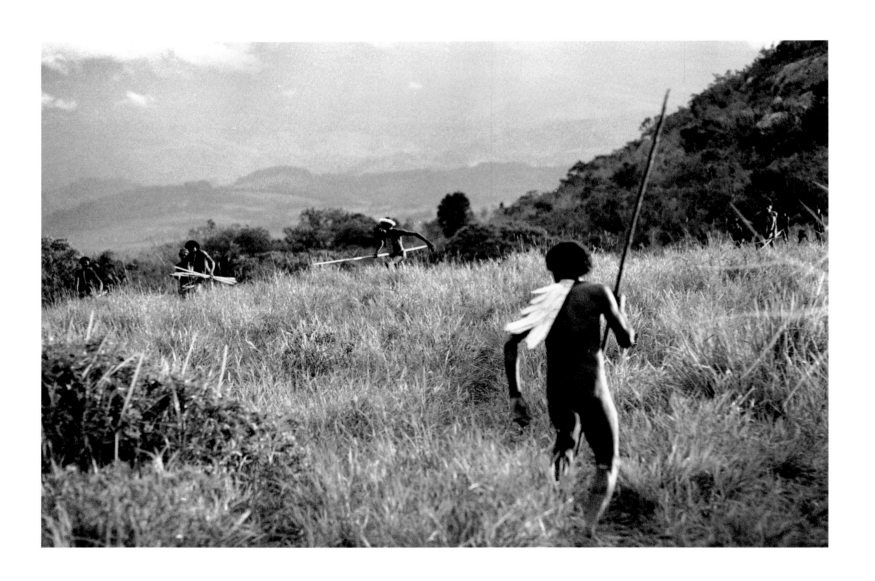

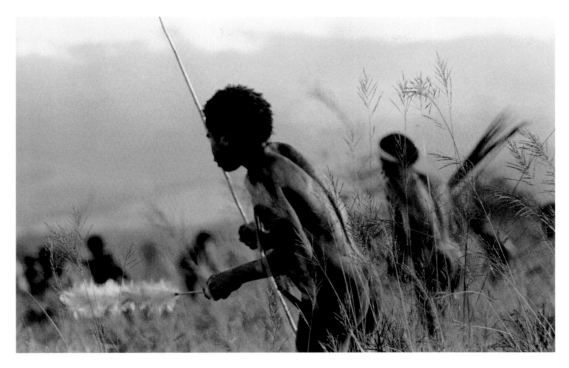

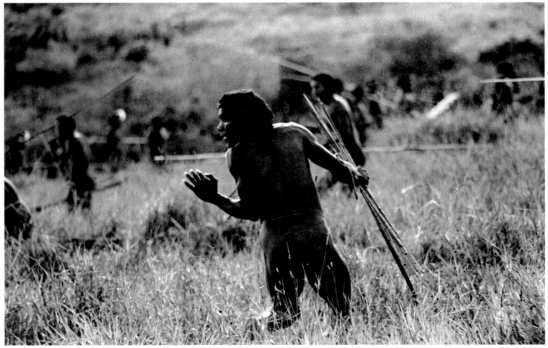

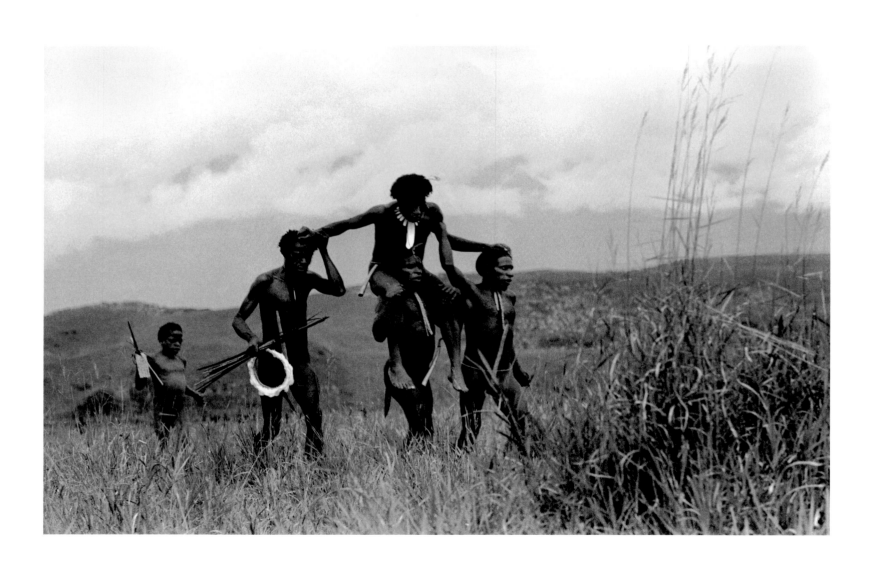

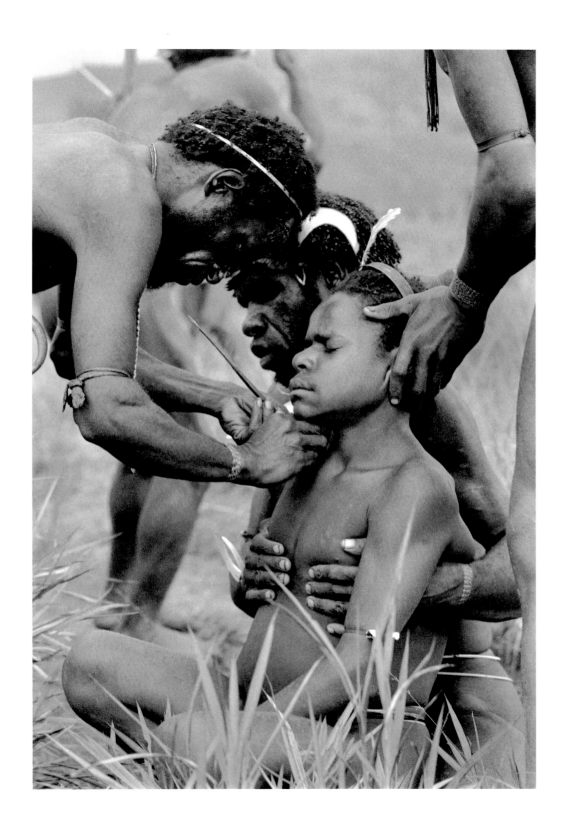

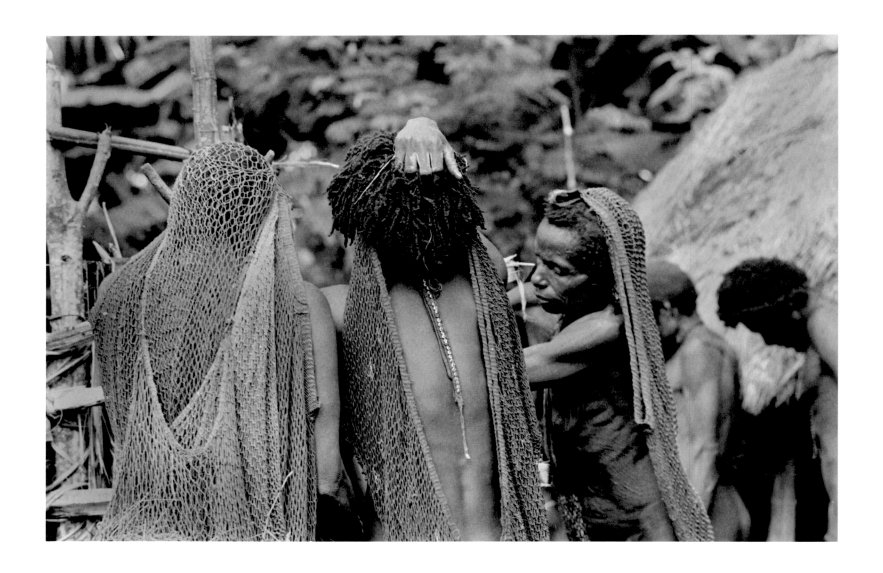

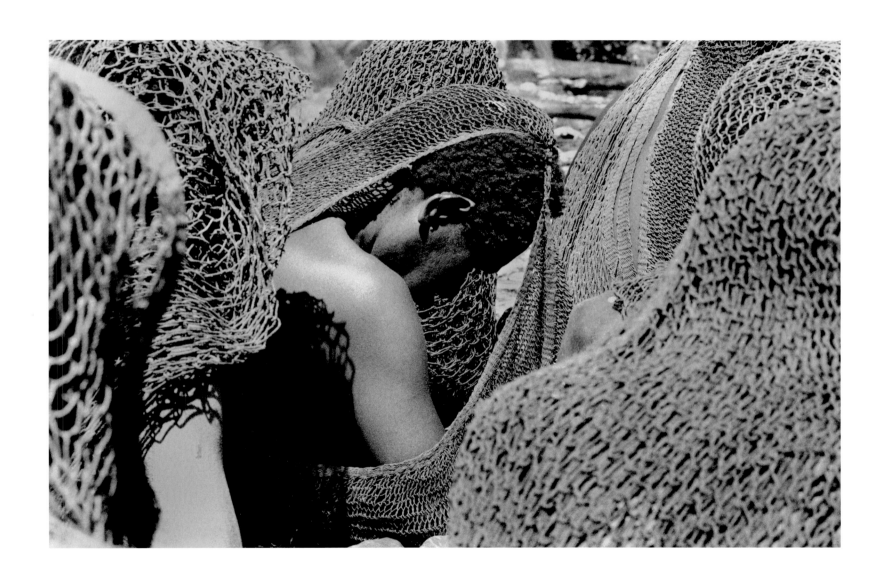

A Dani funeral is an awesome and remarkable occasion. It is held the first full day after death. If the funeral is for a person recently killed by the enemy (a "fresh-blood funeral"), soon after the sun rises a chair is made from sticks of *kai* wood, the same wood used to construct the watchtowers.

—Robert Gardner

The monotonous moaning comes in response to a chanted few words from a man or woman. The women gathered closely around the seated dead man are related to the dead man and responsible for most of the moaning . . .

 The man whose voice is prominent seemed to have been important in the ceremony; he often led the moaning and often loudly sounded his grief. This man becomes the fore-singer; he stands before the throned corpse . . . His voice shakes with grief; as he chanted, tears ran down his cheeks and his hands shook as he raised them occasionally toward the corpse.

—Michael Rockefeller, April 26, 1961

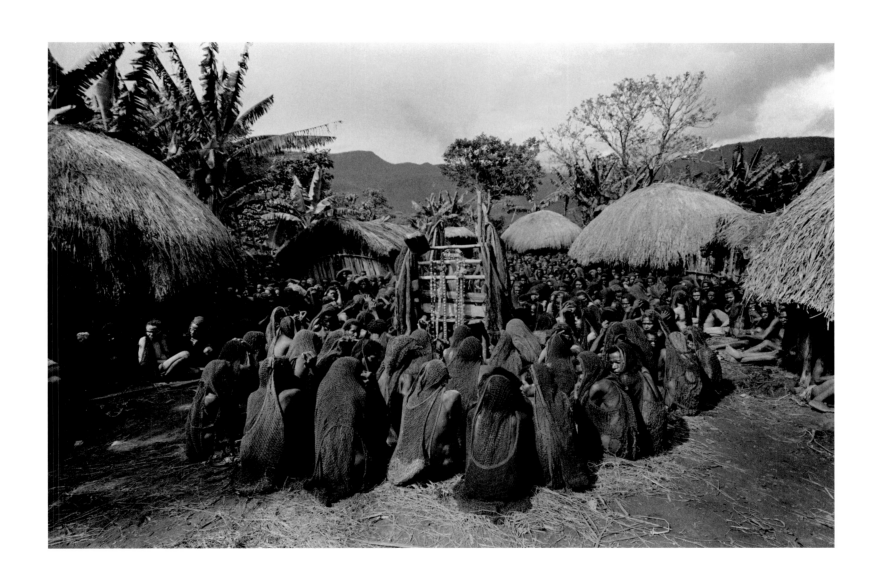

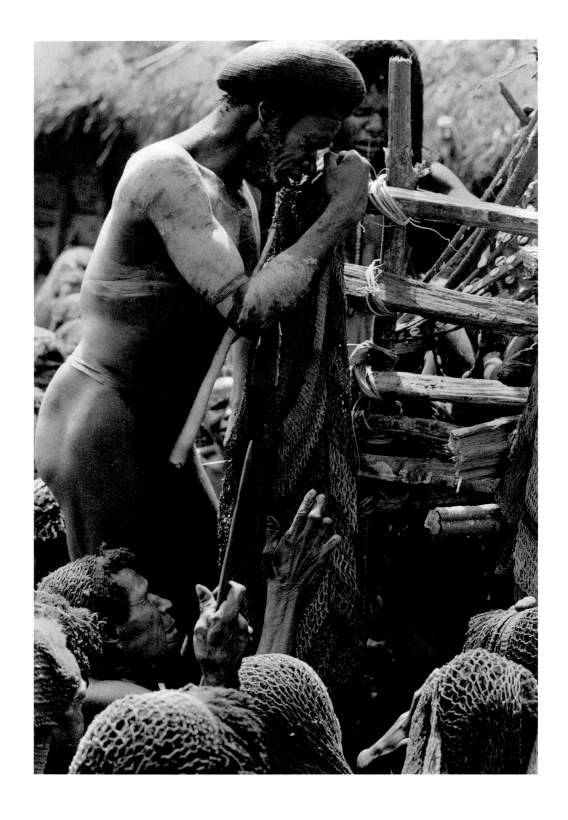

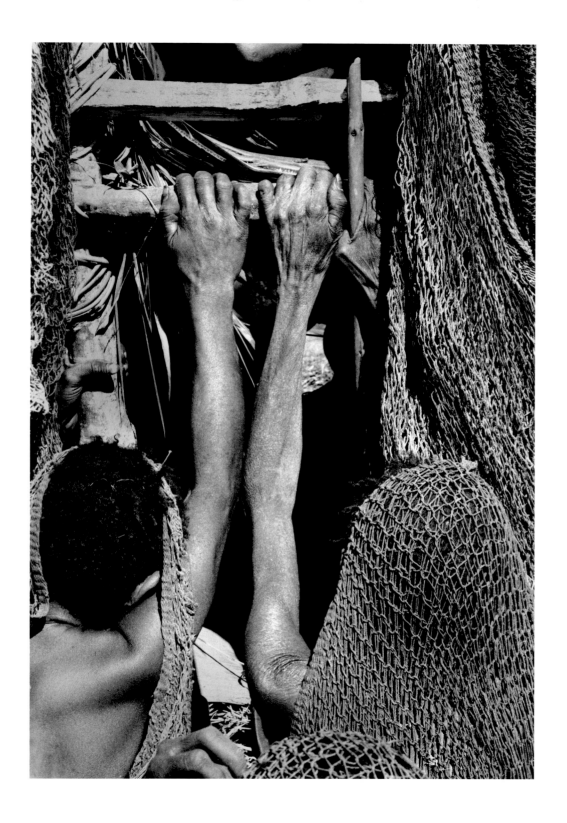

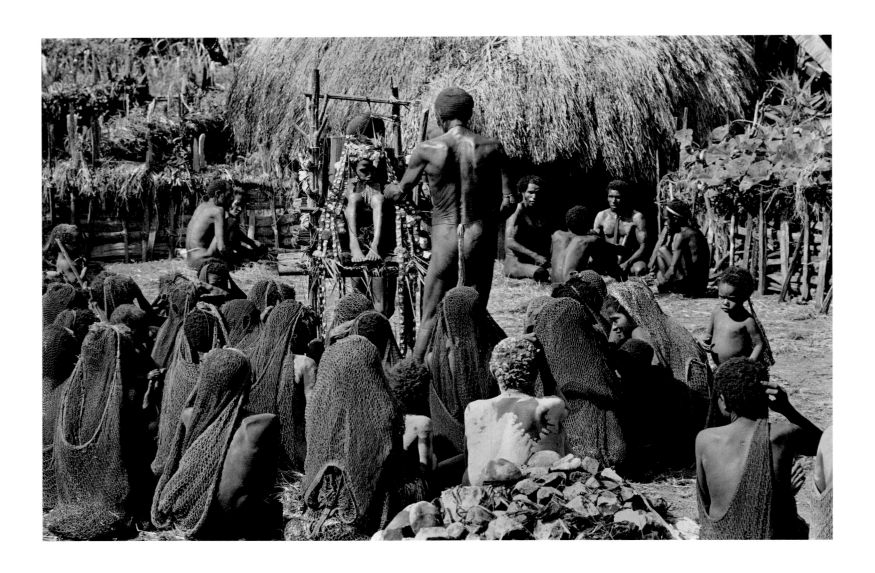

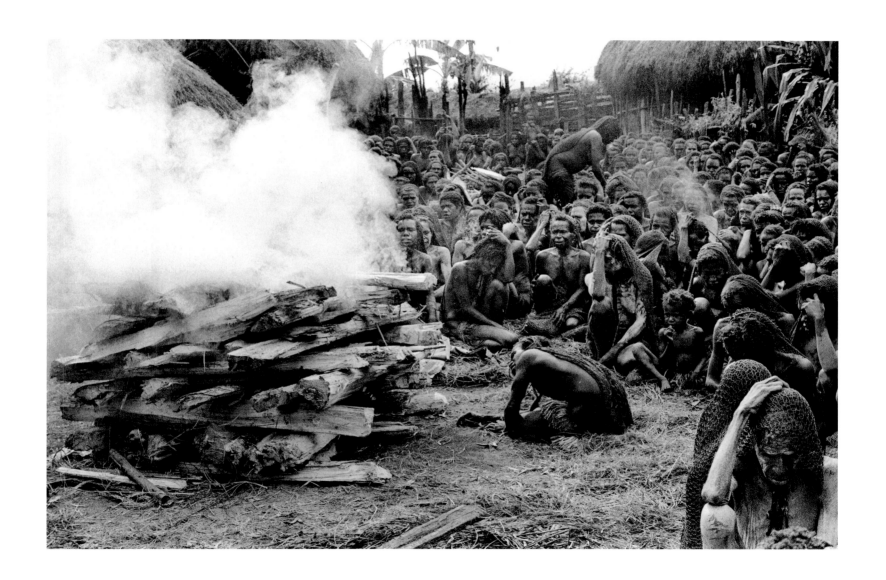

Both sexes give ample indication of their grief, but women, especially those most closely linked to the dead by kinship or by marriage, seem driven by a deeper passion. The mourning chants the women sing do not cease until night has fallen and everyone who does not live in the funeral village has left. Those who stay will cry until the sun rises once more.

—*Robert Gardner*

The funeral mourning—the sound is eerie, distant, and empty-like. Then women mourning—all are caught up in the pulse of the elegy—sounds really like a "dying wind."

—*Michael Rockefeller, June 11, 1961*

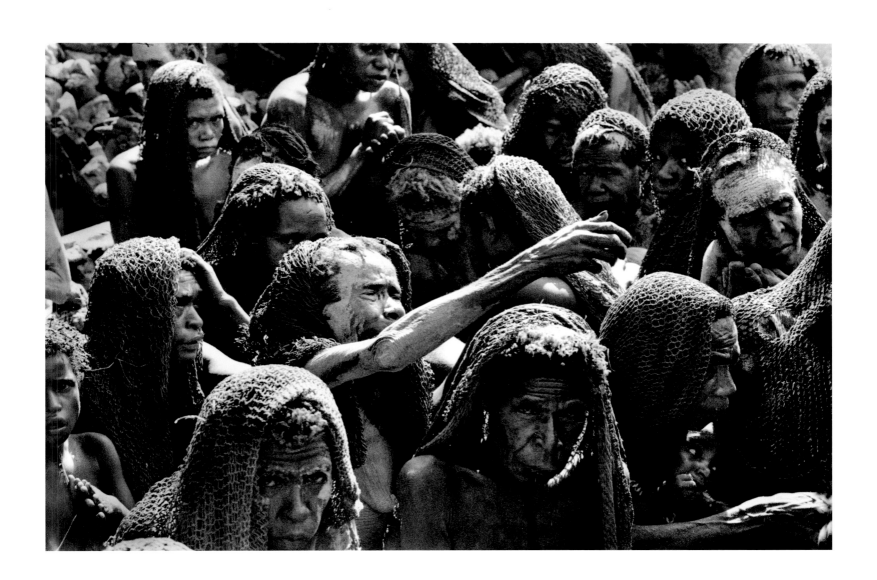

The appointment of the surgeon-magician with the little girls chosen to sacrifice a finger falls at dawn on the morning following the cremation. The child may cry or not. Each knows that what has happened had to happen, and that it will happen again. The girl's hand is bound tightly with banana leaves, and the child will hold up her proud green fist for the rest of the day.

—*Robert Gardner*

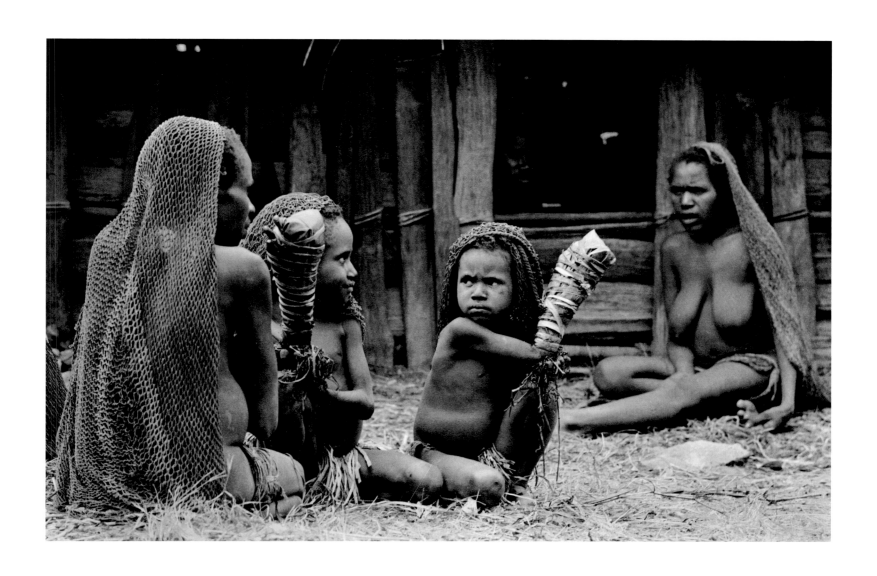

We awoke to the sound of distant voices singing a high-pitched chorus far out on the dance ground. Eventually we learned that the voices we heard were raised in a victory celebration. The songs were chants they would sing all day as they rejoiced at the news that an enemy had died from wounds received in a recent battle.

—*Robert Gardner*

Etai. The scene of the wildly dancing groups . . . was completely beyond my expectations. I was so eager to tape sound, take pictures, and steer clear of Bob's movie camera, whose whereabouts I was not sure of, that I lost my head. The final touch came when someone ran off with the knapsack carrying all my tapes.

—*Michael Rockefeller, May 10, 1961*

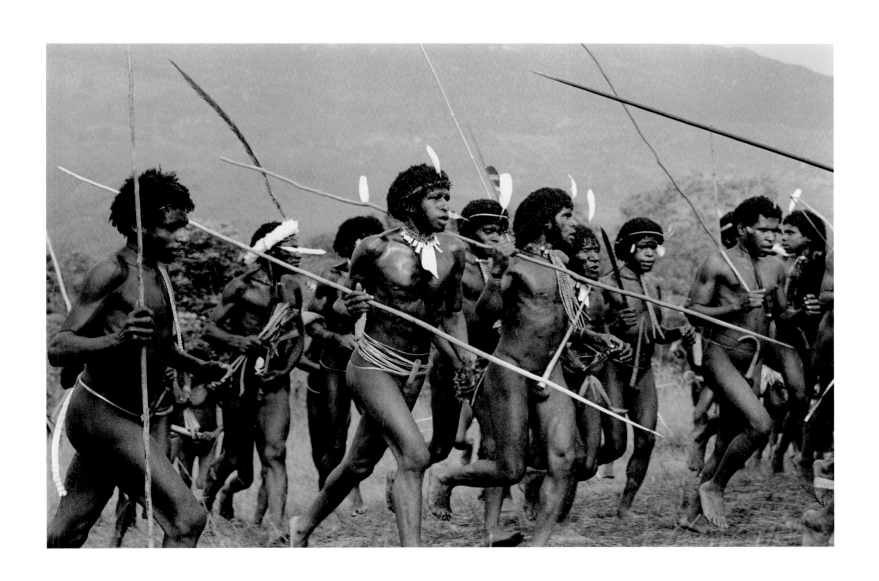

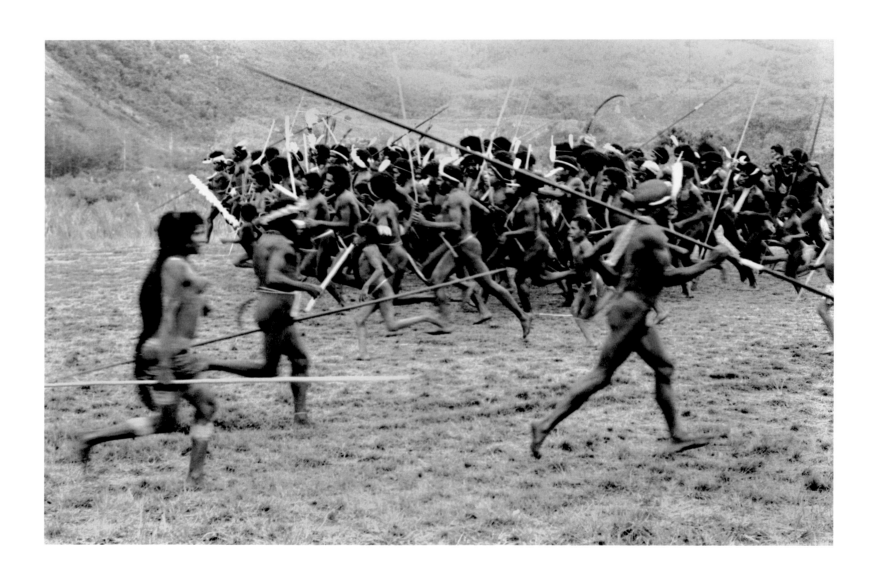

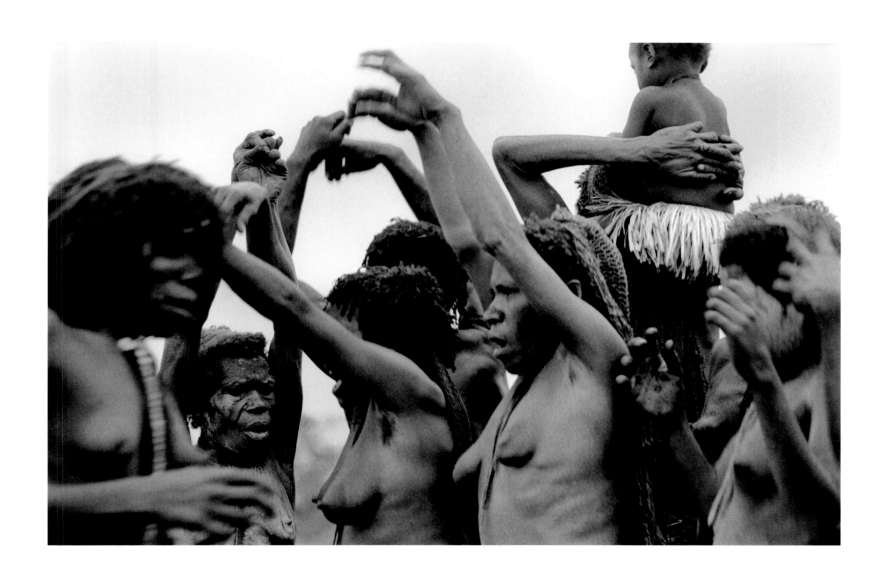

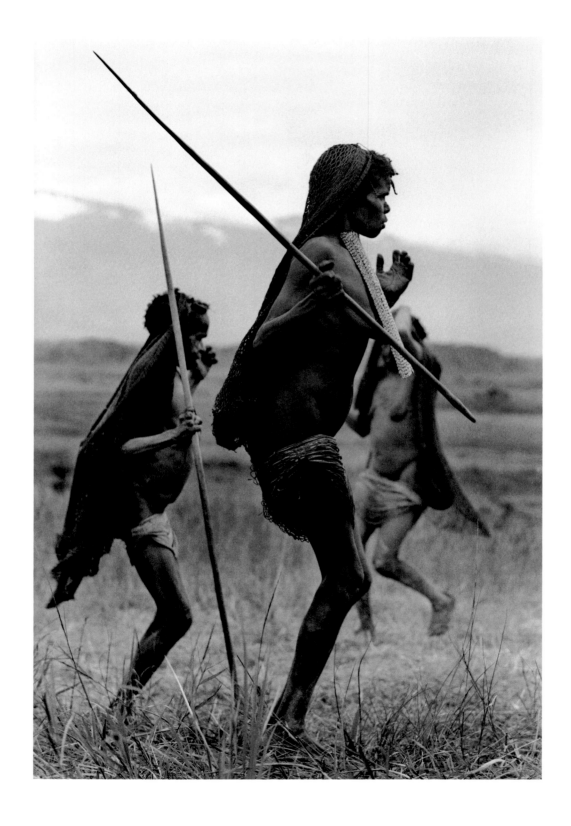

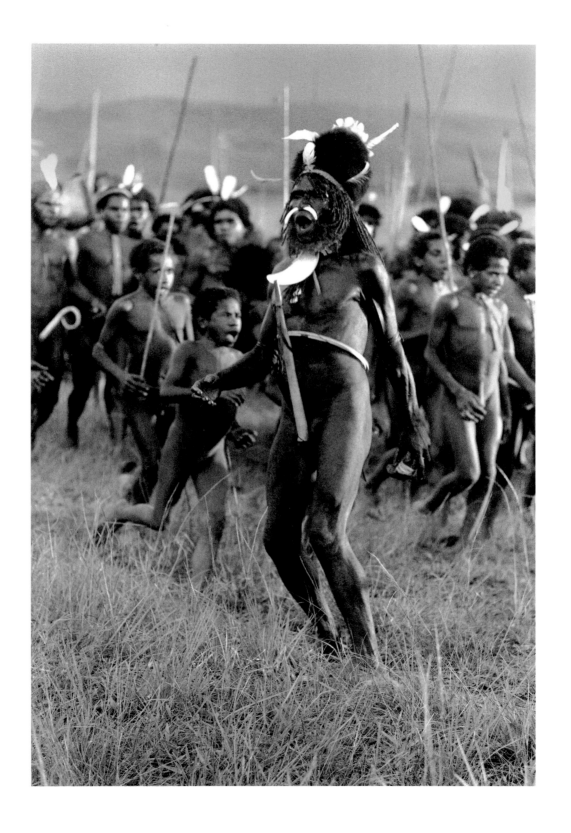

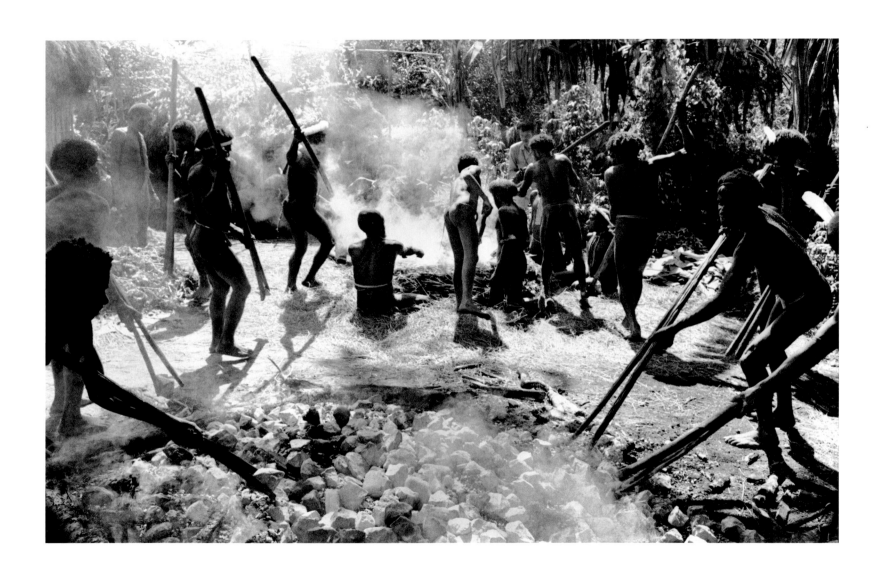

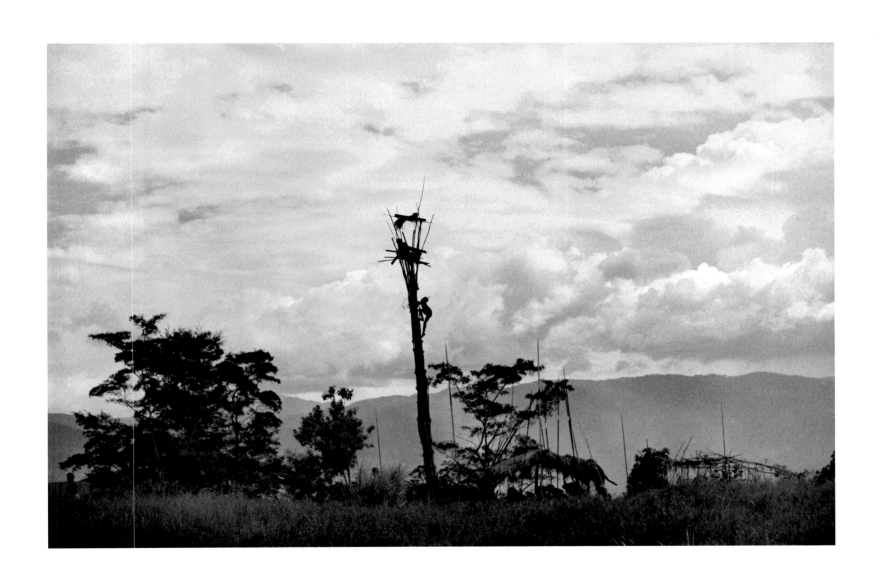

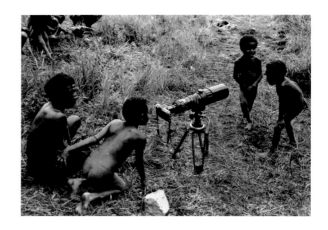

Michael Rockefeller

Michael Clark Rockefeller (1938–1961) graduated in 1960 from Harvard College, where he majored in history. The year following his graduation he joined the Harvard-Peabody New Guinea Expedition, which he also helped to fund. After some six months in New Guinea, Rockefeller visited filmmaker Robert Gardner, the expedition's leader, in Cambridge in the fall of 1961. Together they reviewed hundreds of photographs taken by the expedition members and agreed that the young photographer would edit a book of these images of the Dani.

After a brief stay in the United States, Michael Rockefeller returned to New Guinea to visit the Asmat people, among whom he planned to both photograph and collect traditional art. In November 1961 Rockefeller disappeared off New Guinea's southern coast after his large raft, mounted on two dugout canoes, capsized.

In 1967, Adrian Gerbrands edited the book *The Asmat of New Guinea: The Journal of Michael Clark Rockefeller.* The book of Dani photographs that Michael was to have edited was eventually written by Robert Gardner and Karl G. Heider, who published the now-classic *Gardens of War* in 1968.

In memory of his youngest son, Nelson Rockefeller funded the construction of the Michael C. Rockefeller Wing at the Metropolitan Museum of Art in New York City. The wing displays the arts of Africa, Oceania, and the Americas, including most of the objects that Rockefeller collected among the Asmat. Harvard's Peabody Museum of Archaeology and Ethnology owns two pieces collected by Rockefeller during his second New Guinea expedition: two long *bis* poles, intricately carved wooden objects once associated with Asmat head-hunting rituals. Michael Rockefeller's photographs of the Dani reside in the archives of the Peabody.

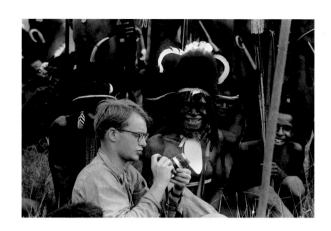

The Michael C. Rockefeller Memorial Fellowship

The Michael C. Rockefeller Memorial Fellowship was established at Harvard University in 1966. Michael's family and close friends chose to honor the young anthropologist's love of adventure, sensitivity, and goodwill by nurturing those same qualities in other young men and women. The fellowship provides selected Harvard graduates a year of exploration, challenge, and discovery in a culture not their own. The experience yields a deeper understanding of our common human experience through respectful and significant interaction with peoples of other cultures.

In 2006 the fellowship celebrates its fortieth year of providing support to recent graduates who demonstrate the qualities for which Michael is remembered: a seriousness of purpose, a creative independence of mind and heart, a warm interest in people of all cultures, and a sincere concern for their struggles and challenges. To date, 160 fellows have received this award.

The Peabody Museum thanks the Michael C. Rockefeller Memorial Fellowship for its generous support of this publication.

Michael C. Rockefeller Memorial Fellowship
54 Dunster Street
Cambridge, MA 02138

Acknowledgments

I thank Robert Gardner for suggesting that I curate an exhibition of Michael C. Rockefeller's Dani photography at Harvard's Peabody Museum of Archaeology and Ethnology. During our twenty-three-year friendship, Robert has been a guiding force for my own photographic image making and a colleague who has enriched my understanding of those who bring back still and moving images from remote corners of the world.

Robert also has kindly provided captions for the photographs and allowed us to quote liberally from his text to *Gardens of War*. Robert and his wife, Adele Pressman, have been generous hosts and wonderful friends over years of visits between my home in Vermont and theirs in Cambridge.

At Studio7Arts, Brian Schwartz, with his careful attention to all our concerns, has been Robert's and my invaluable right-hand man, stepping up to accomplish each and every task we put his way.

The bright light and optimistic spirit behind this book has been Joan O'Donnell, the editorial director of the Peabody Museum Press. Working from Santa Fe, Cambridge, and Obsidian, Idaho, Joan has devoted her creative energy, humor, and diplomacy to every aspect of this project. Katrina Lasko has given the photographs and text a fresh vision through her elegant design of the book. At the press, Donna Dickerson's careful attention to all details of production has been invaluable. Cathy Armer was a perceptive and meticulous copyeditor.

I am grateful to Joan O'Donnell, Ilisa Barbash, Jeffrey Quilter, and William Fash for their careful readings and useful comments on the text. Melissa Banta gave the manuscript an exceptionally useful review.

Peabody Museum Director William Fash, Deputy Directors Rebecca Chetham and Jeffrey Quilter, Associate Curator Ilisa Barbash, Director of External Relations Pamela Gerardi, and Exhibit Designer and Coordinator Sam Tager have given inspired support in planning, preparing, executing, and promoting the exhibition. Registrar Genevieve Fisher and Assistant Registrar Amy Wolff Cay have kept Michael Rockefeller's negatives in excellent order, along with the vintage and new prints used in the exhibit, and Imaging Services Coordinator Julie Brown has cheerfully provided needed scans of the negatives and prints.

I thank Michael Rockefeller for making the photographs. It has been a great pleasure to spend time with them. Many questions about Michael's work among the Dani will remain unanswered, but I hope this book will be an enduring testament to his photographic accomplishments.

Finally, I thank my wife Laura McKeon, our daughter Tara, and our son Ryan for their love and encouragement.

Kevin Bubriski
Shaftsbury, Vermont
October 2006

The Photographs

All photographs are by Michael Rockefeller, except as noted below, and all are copyright the President and Fellows of Harvard College.

Frontispiece: Warriors wait on the Warabara Ridge, PM2006.12.1.83.11 (191-11)

iv: Michael Rockefeller in New Guinea, 1961. Photo by Jan Broekhuijse, PM2006.15.1.19.30 (95-30)

2: Looking back, PM2006.12.1.22.27 (52-27)

4: Gathering for war, PM2006.12.1.50.15–18 (101-15–18)

5: Watching the *etai* (victory dance), PM2006.12.1.3.33–36 (9-33–36)

7: Contact sheet; boys playing war games, PM2006.12.1.69.2–31 (168-2–31)

8: Watching the battle from above, PM2006.12.1.83.9 (191-9); see p. 54

9: Kousa with his new dog, PM2006.12.1.95.27–30 (243-27–30)

10 top: Jeering at the enemy, PM2006.12.1. 89.33–36 (225-33–36)

10 bottom: Exulting warrior, PM2006.12.1.95.6 (243-6); see p. 53

11: Climbing a watchtower, PM2006.12.1.116.6 (298-8)

12 left: Removing an embedded arrow PM2006.12.1.92.17 (233-17); see p. 61

12 right: Wounded warrior, PM2006.12.1.91.17 (232-17); see p. 60

13 left: Girls with amputated fingers, PM2006.12.1.55.23 (112-23); see p. 73

13 right: Grieving woman, PM2006.12.1.58.21 (122-21); see p. 71

14 left: Victory dancing, PM2006.12.1.99.9 (255-9); see p. 77

14 right: En route to the salt well, PM2006.12.1.45.27 (91-27); see p. 21

15: Dani men at play in Michael's tent, PM2006.12.1.22.12–24 (52-12–24)

17: Men cultivating, PM2006.12.1.40.34 (82-34)

18: An idle moment, PM2006.12.1.30.18 (64-18)

19: Childhood friends, PM2006.12.1.114.25 (287-25)

20: Restoring an irrigation ditch, PM2006.12.1.76.27 (176-27)

21: En route to the salt well, PM2006.12.1.45.27 (91-27)

22: Drinking at the Aikhe River, PM2006.12.1.102.29 (262-29)

23: Inside the family home, PM2006.12.1.106.4 (272-4)

24: Men grooming each other, PM2006.12.1.52.15 (106-15)

25: An offering of sweet potatoes, PM2006.12.1.54.27 (111-27)

26: House rebuilding, PM2006.12.1.38.29 (79-29)

27: Men gardening, PM2006.12.1.70.26 (169-26)

29: Playing war with toy spears and a vine hoop, PM2006.12.1.102.22 (262-22)

30: Playing "kill the hoop," PM2006.12.1.69.3 (168-3)

31 top: Playing at war, PM2006.12.1.25.9 (55-9)

31 bottom: Boys practicing to become warriors, PM2006.12.1.69.31 (168-31)

32: Boys at play, PM2006.12.1.38.37 (79-37)

33: Playing with toy bow and arrows, PM2006.12.1.99.37 (255-37)

Selected Bibliography

Gardner, Robert. *The Impulse to Preserve: Reflections of a Filmmaker.* New York: Other Press, 2006.

Gardner, Robert, and Karl G. Heider. *Gardens of War: Life and Death in the New Guinea Stone Age.*
New York: Random House, 1968.

Gerbrands, Adrian A. *The Asmat of New Guinea: The Journal of Michael Clark Rockefeller.*
New York: Museum of Primitive Art, 1967. Distributed by New York Graphic Society.

Heider, Karl G. *The Dugum Dani: A Papuan Culture in the Highlands of West New Guinea.*
Chicago: Aldine Publishing, 1970.
——. *Grand Valley Dani: Peaceful Warriors.* 3rd ed. Fort Worth: Harcourt Brace, 1997.
——. *The Dani of West Irian: An Ethnographic Companion to the Film "Dead Birds."* Andover, MA:
Warner Modular Publications, Module 2, 1972. Reprint, Piscataway, NJ: Aldine Transaction, 2006.

Matthiessen, Peter. *Under the Mountain Wall: A Chronicle of Two Seasons in the Stone Age.*
New York: Viking Press, 1962.

MICHAEL ROCKEFELLER
New Guinea Photographs, 1961

Quotations from Michael Rockefeller are adapted from "Sound Recordings, Grand Valley Dani; Michael Rockefeller, 1961; Harvard Peabody Expedition to Netherlands New Guinea." Peabody Museum Archives 2005.15 A, B, C. Gift of the Family of Michael Rockefeller.

Quotations from Robert Gardner are excerpted with the author's permission from *Gardens of War* by Robert Gardner and Karl G. Heider © 1968 by the Film Study Center, Peabody Museum, Harvard University.

Published by the Peabody Museum Press
Peabody Museum of Archaeology and Ethnology
Harvard University
11 Divinity Avenue
Cambridge, Massachusetts 02138
www.peabody.harvard.edu/publications/

Published in conjunction with an exhibition at Gallery 12, Peabody Museum of Archaeology and Ethnology, November 15, 2006–February 28, 2007

Compiled and edited by Joan Kathryn O'Donnell
Designed and composed by Katrina Lasko
Production management by Donna Dickerson and Katrina Lasko
Copyedited by Cathy Armer
Duotone separations and printing by Capital Offset Company, Inc.
Bound by New Hampshire Bindery

Printed and bound in the United States of America

ISBN 0-87365-806-X

♾ The paper used in this publication meets the minimum requirements of the American National Standard for Information Sciences–Permanence of Paper for Printed Library Materials, ANSI Z39.48-1984.

Front cover: Dani boys playing "kill the hoop." Photo by Michael Rockefeller, PM2006.12.1.69.3 (168-3).
Back flap: Michael Rockefeller, 1961. Photo by Jan Broekhuijse, PM2006.15.1.1.29 (7-29).
Back cover: Dani warriors waiting for battle. Photo by Michael Rockefeller, PM2006.12.1.17.3 (37-3).